Discovering Totem Poles

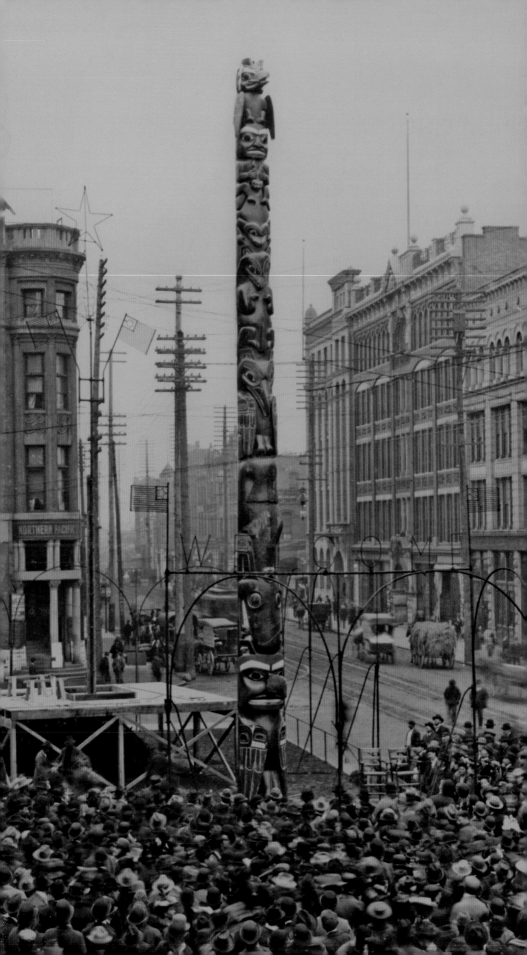

Aldona Jonaitis

Discovering
TOTEM POLES

A TRAVELER'S GUIDE

A Ruth E. Kirk Book

UNIVERSITY OF WASHINGTON PRESS
Seattle & London

Douglas & McIntyre
D&M PUBLISHERS INC.
Vancouver/Toronto

This book is published with the assistance of a grant from the Ruth E. Kirk Endowed Book Fund, which supports publications that inform the general public on the history, ecology, archaeology, and native cultures of the Pacific Northwest.

© 2012 by the University of Washington Press
Printed and bound in China
Design by Thomas Eykemans
17 16 15 14 13 12 5 4 3 2 1

University of Washington Press
PO Box 50096, Seattle, WA 98145, USA
www.washington.edu/uwpress

Library of Congress Cataloging-in-Publication Data
Jonaitis, Aldona, 1948–
Discovering totem poles : a traveler's guide / Aldona Jonaitis.
 p. cm.
"A Ruth E. Kirk Book."
ISBN 978-0-295-99187-0 (pbk. : alk. paper)
1. Totem poles—Guidebooks.
2. Indians of North America—Northwest Coast of North America—Antiquities—Guidebooks.
3. Northwest Coast of North America—Guidebooks.
I. Title.
E98.T65J65 2012 731'.77—dc23 2011049725

Published simultaneously in Canada by:

Douglas & McIntyre
An imprint of D&M Publishers Inc.
2323 Quebec Street, Suite 201
Vancouver BC Canada V5T 4S7
www.douglas-mcintyre.com

The paper used in this publication meets the minimum requirements of American National Standard for Information Sciences—Permanence of Paper for Printed Library Materials, ANSI Z39.48–1984.∞

CONTENTS

ACKNOWLEDGMENTS

THE FIRST TO BE ACKNOWLEDGED IN A BOOK ON TOTEM POLES ARE those talented carvers, past and present, who made these magnificent sculptures, as well as the families who sponsored their creation. You have enriched my life immensely since I first saw your artistic heritage at the American Museum of Natural History so many decades ago.

The second acknowledgment for this book goes to Aaron Glass, my coauthor on *The Totem Pole: An Intercultural History*. Aaron did just about all the research that went into that volume, and I credit him for many ideas on poles that appear in both publications. I also thank Aaron for his reading and comments on the manuscript, and for the use of his photographs reproduced here.

Numerous others helped in various ways with the creation of this book. My dear friend Janet Catherine Berlo graciously agreed to read the manuscript and I thank her heartily for her words about it. As always, my friends at the University of Washington Press, Jacqueline Ettinger, Denise Clark, and Mary Ribesky, worked their usual wonders to turn computer printouts and digital photos into a lovely book.

I have much appreciated help with the photographs from Martha Black, of the Royal British Columbia Museum, and Robin Wright, at the Burke Museum of Natural History and Culture. Special thanks to Patty Kastelic, who went with me to Ketchikan and loaned me her excellent camera and took some of the photos illustrated here. Special thanks also go to Nicolas Galinin, who took time from his artistry to photograph a pole in Sitka.

Several artists have taken time to discuss their poles with me and I thank those whose art appears in both books: Donald Varnell, Nathan Jackson, Stephen Jackson, Richard Hunt, Susan Point, and David Boxley. I thank those whose poles I publish here for the first time: Tommy Joseph, Richard Beasley, Wayne Price.

And, finally, I thank you, readers, who have shared my fascination with totem poles enough to pick up this book and, I hope, are learning something new and different about these beautiful carvings.

INTRODUCTION

THE TOTEM POLES THAT STAND IN CITIES AND TOWNS FROM SEAT-
tle to Anchorage captivate many tourists who sail the Inside Passage, a
glorious route along the mountain-framed, sheltered waters of coastal British
Columbia and Southeast Alaska. Historically, poles were raised for a variety
of reasons: as mortuaries for the remains of the deceased, as memorials to
notable family members, and as expressions of a family's history and posi-
tion in the community. The art form is old and predates contact with the
first Euroamerican explorers who sailed the waters of the Northwest Coast
in the late eighteenth century. However, those earliest poles had a distribu-
tion limited to the Tsimshian peoples of northern British Columbia as well as
the Haida of Haida Gwaii (Queen Charlotte Islands) and Southeast Alaska.[1]
Beginning in the early nineteenth century, the making of totem poles spread
north to the Tlingit in Alaska. Later poles diffused south to the Nuxalk,
Kwakwaka'wakw, and Nuu-chah-nulth. Today they stand from Alaska to
Washington State and beyond. Museums in the United States, Canada,
Europe, Japan, and elsewhere around the globe proudly exhibit totem poles;
some are historic pieces collected in the late nineteenth and early twentieth
centuries, others have been made within the last forty years.

In 2010 my colleague Aaron Glass and I published *The Totem Pole: An
Intercultural History*, in which we presented these carved monuments not
as static forms of an ancient Indian art form but instead as products of the
dynamic and ongoing history of Native interactions with those who visited
and settled in their land. We called our book "an intercultural history" to
highlight the numerous and varied participants. These included Native peo-

1 Opinions differ on whether the pole form originated among the Haida or the Tsimshian.
It is probably not possible to decide this question.

ple for whom these monuments communicated important information about their families and culture, tourists who found them captivating, missionaries who sought to eradicate them, museums that collected them, government agencies that preserved them, individuals and organizations who appropriated them for their own uses, and Native groups who asserted ownership over their heritage in the form of these poles during the later twentieth and early twenty-first centuries.

This book is intended to present the histories of a number of poles, focusing on how each one came about as the result, in part, of the interactions between Native and non-Native people. The title of each section gives an indication of what specific theme will be discussed, such as the relationship of that pole to laws that limited Native freedoms, to the ill effects of colonialism on Native traditions, to the dispossession of Native lands, and to the current resurgence of Native control over their heritage. Unlike other guidebooks on totem poles, this book demonstrates that the pole is not a category of Native art invented hundreds of years ago that maintained its original significance, but is, instead, a type of art that has over the decades been transformed by the colonial encounter.

People often wish to know the identity of a pole's symbolic images, and with the proper key that is often possible. A raven has a pointed beak, an eagle a curved one. The bear has prominent ears, sharp canines, and large paws with claws. And the beaver, with its oversized incisors and crosshatched tail often carries a stick to chew. Although this is a start, knowing the animal species depicted provides little real information on the pole's true significance. Most of these images represent crests, beings that at some time in the past bestowed privileges upon a family or the ancestors who interacted with and obtained the right to depict those beings and tell their stories. An animal image on two works of art, two depictions of bears, for example, might look the same, but if they were made for separate families, they would represent different beings or be associated with distinct histories.

Only family members have the right to tell their specific crest histories. Over the years, many families have shared their stories, some of which ultimately appeared in various publications. For example, *The Wolf and the Raven*, by Linn Forrest and Viola Garfield, interprets poles at Saxman, Totem Bight, Ketchikan, and Klawock in Southeast Alaska; Marjorie Halpin's *Totem Poles: An Illustrated Guide* describes the meaning of poles at the Museum of Anthropology (MOA) in Vancouver; and Vickie Jensen's *The Totem Poles of Stanley Park* covers a stand of poles in Vancouver. Hillary Stewart's *Looking at Totem Poles* treats much the same region as this book, explains the imagery on a good many of the poles discussed here, and provides a key for

identifying various crest images. In addition, many museums, towns, and Native communities offer visitors interpretations of their poles. Because we respect the family ownership of crests and their stories, Aaron Glass and I avoided detailing the histories of specific poles in our earlier book, directing readers instead to the existing literature containing such information. I do the same in this publication.

So why read this book? Consider an equestrian statue in a city square. If someone ignorant of horses, history, and the Western art tradition asked what the sculpture represented, would it be sufficient to answer "a horse and a rider"? Of course not—although that would be equivalent to identifying a raven and frog on a totem pole and leaving it at that. Yet even if you learned the individual's name and his accomplishments (most equestrian statues depict men), these would mean little without understanding the broader social and cultural significance that identifies the rider's place within his historical epoch.

In this book, I present the kind of information that places various totem poles you see along the Inside Passage within the broader social, cultural, and artistic context that emerged, and continues to emerge, from the interconnections of the First Nations of the Northwest Coast and the settlers on their lands. But before I go into individual poles some general information is useful:

Poles raised in Native communities communicate information about the history and prestige of the families who owned them

When a family wishes to raise a totem pole, it hires a carver. The carver (usually male, until the twentieth century) was instructed by the family about the imagery to be carved. The actual raising of the pole is a great event, accompanied by a celebration of feasting, oration, and dancing called a *potlatch*. Toward the end of this event, the hosts give their guests gifts such as blankets, boxes, and sometimes even cash; by accepting these gifts, the guests validate their host's ownership of the crests they display, as well as the position of the family in the political hierarchy of the group. From one perspective, the most important feature of the totem pole is not its permanent presence before a house, or even its size and artistry, but the potlatch that celebrates its erection.

Poles were never worshipped nor were they sacred

When missionaries arrived in British Columbia and Alaska in the last decades of the nineteenth century, they equated totem poles with paganism and insisted all new converts renounce any association with them. These

foreigners, blind to the social and political nature of the poles, accused the Native people of worshipping these monuments. An indication of how Native people accommodated to their new conditions while maintaining certain significant cultural traditions is that after many Northwest Coast converts ceased raising poles, they placed their bears, ravens, killer whales, and other crest images on their Christian tombstones, thus perpetuating in a new context the importance of crest display.

Most poles you see outdoors are less than one hundred years old

Totem poles are carved from cedar, a highly rot-resistant wood that grows in the southernmost islands of Alaska and on the British Columbia coast. Despite its strength, even cedar cannot resist the elements in this temperate rain forest forever, and totem poles eventually decay. Thus, most poles you see outside are no older than one hundred years, and the oldest of these have often been treated with preservatives or repainted. The vast majority of poles on the Inside Passage were made after the 1930s.

Most poles you see inside museums are less than two hundred years old

After 1880, museums began acquiring totem poles from the Northwest Coast. Few had been carved before 1800, so when the poles first arrived at museums the oldest were no more than eighty years old. If left outside, these poles would certainly have decayed, but inside a museum their life spans were extended, especially if conserved with state-of-the-art methods.

Some poles you see are copies of older poles

Before contact with Euroamericans, the estimated Native population for the region from Yakutat Bay in Alaska to northern California was 184,000. People lived in relatively small villages with sheltered beaches for landing canoes, flat enough land to build houses, and a source of fresh water. Beginning in the 1820s the Hudson's Bay Company established trading forts where Native people could earn good money for their furs. Throughout the nineteenth century, families left their original villages and moved closer to the trading posts, forming amalgamated communities composed of people who had lived in separate locations earlier. Another reason for such moves was disease: even before the time Euroamericans landed on the Northwest Coast, epidemics that spread from the south, where non-Natives lived, had periodically ravaged communities. Especially hard-hit were the Haida, where

in 1862 smallpox left only one out of ten people alive. Those survivors moved to villages with viable remaining populations. Poles from the original villages were sometimes copied and erected in front of new homes. This practice of replicating old poles has continued throughout the twentieth century and contributed to the large number of poles standing today in British Columbia and Alaska.

The concept of "low man on the totem pole" is meaningless, and the "totem" of totem pole is a misuse of the term

The position of an image on a totem pole has no relevance to its importance. And totemism is, strictly speaking, an anthropological term for a particular type of belief in which a clan believes itself to be descended from a particular protective animal (the totem) that the clan may not kill or eat. Unlike the totem proper, a crest being is not the ancestor of a clan, nor is it necessarily taboo to eat.

• ◆ •

In this book, I illustrate more than fifty totem poles that can be seen in various communities along the Inside Passage. This survey begins in Seattle, then goes to Victoria, Vancouver, Vancouver Island, Prince Rupert, Haida Gwaii (the official name of the Queen Charlotte Islands), Ketchikan, Sitka, and Juneau. I selected this small group of poles for several reasons. First, they are relatively easy to get to see. But they also span the chronological period from the late nineteenth century to the present. Some have appeared in numerous publications and are thus familiar to those who know Northwest Coast art, while others are unfamiliar to most people. I hope you enjoy looking at these wonderful carvings and learning about their multifaceted, rich, intercultural histories.

Discovering Totem Poles

Tsaxis
(Fort Rupert)

'Yalis
(Alert Bay)

Port McNeil

Gwa'yasdams (Gilford Island)

KWAKWAKA'WAKW

COAST SALISH

NUU-CHAH-NULTH

STRAIT OF GEORGIA

Vancouver

Musqueam

PACIFIC
OCEAN

Duncan

CANADA

UNITED STA

Victoria

STRAIT OF JUAN DE FUCA

N

Seattle
1 2

50 MILES

50 KILOMETERS

SEATTLE

1 THE SEATTLE TOTEM POLE AT PIONEER SQUARE:
THEFT AND THE SYMBOL OF A CITY

The totem pole that today stands on Pioneer Square in Seattle has an intriguing history that includes theft, deceit, and arson (fig. 1). Before 1899, the original of this Tlingit pole stood in the village of Tongass, located in the southernmost region of the Alaska panhandle. That year, a group of Seattle businessmen went north on a steamship trip to investigate possibilities for increasing trade and investment in Alaska. On their return trip south, they stopped at Tongass and, seeing few people, decided the village was abandoned and that they could take whatever seemed interesting. Some members of the group found one sixty-foot-tall totem pole so impressive that they had it chopped down, sawed in half, and towed to their ship. They would donate to the city of Seattle this wonderful "trophy" of their successful expedition.

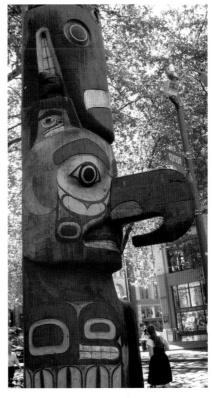

1 Tlingit, Seattle totem pole.
Photo by Aldona Jonaitis, 2010.

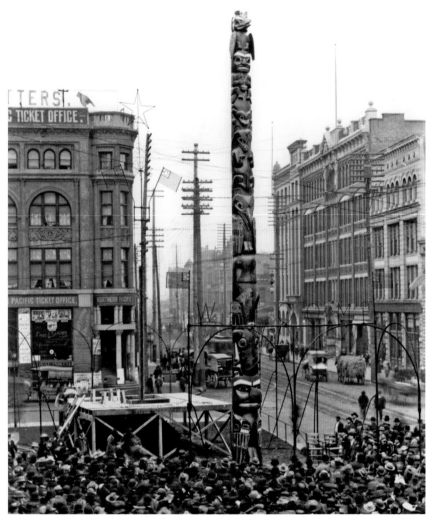

2 Seattle pole dedication, Pioneer Square, Seattle, Washington, 1899. Photo by Anders B. Wiles. University of Washington Libraries, negative no. NA1509.

On October 18, 1899, this pole was raised, amid much fanfare, in Pioneer Square (fig. 2). City notables praised the businessmen who had so thoughtfully brought it to Seattle where it would become the symbol of that great city. One of the speakers assured the assembled crowd that no one owned the pole, and that the group actually saved this treasure which would have certainly been destroyed, if not by missionary's zeal, then by fires. Not mentioned that festive day was the fact that this Tongass pole *was* owned by a Tlingit clan who lived in nearby Ketchikan and had by no means relinquished their claim to this monument.

So incensed was David E. Kininnook, member of the Tlingit clan who owned the stolen pole, that he contacted the territorial governor John Brady (see pp. 65–69), complaining about their treatment. The family demanded

4 SEATTLE

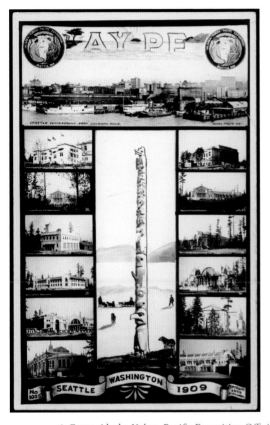

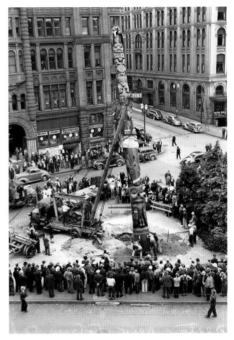

3 Cover, Alaska-Yukon-Pacific Exposition Official Brochure, 1909.
University of Washington Archives, no. 21287; Alaska Pacific Yukon 546.

4 Reinstalling the Seattle totem pole in Pioneer Square, 1940. Staff photographer, *Seattle Post-Intelligencer*. Museum of History and Industry, Seattle, 1986.5.12685.1.

$20,000 for this pole (which was not excessive in terms of the potlatch gifts given away at its raising), but all they eventually received was $500.

Ten years later, in 1909, Seattle hosted the Alaska-Yukon-Pacific Exposition, which celebrated the development of the Northwest region that had begun with the Klondike Gold Rush and transformed Seattle from a small town to a booming city. Front and center on the cover of the Exposition's official brochure was the Seattle pole that had lost all association with its original owners and was now a symbol of civic pride as well as a reminder of business opportunities to the north (fig. 3).

In 1938, an arsonist set fire to the Seattle Totem Pole, which, already dam-

aged by rot, was unsalvageable. Since no one in Seattle at the time had the training required to duplicate this treasure, the city fathers agreed to ship the ruined pole to Ketchikan, where the Civilian Conservation Corps was sponsoring a project to hire Tlingit and Haida men to replicate or restore old poles from surrounding villages (see pp. 51–53). Charles Brown led a team that worked on creating a new version of the Seattle Pole, which was shipped south and raised in Pioneer Square on July 24, 1940 (fig. 4). In 1970, Tsimshian artist Jack Hudson restored and repainted this monumental carving that is now a National Historic Landmark.

2 GRIZZLY BEAR HOUSE POSTS AT THE BURKE MUSEUM OF NATURAL HISTORY AND CULTURE: REPATRIATION, A FATHER AND A SON

In the *Pacific Voices* exhibition at the Burke Museum of Natural History and Culture on the University of Washington campus are two strikingly different artworks, one by Tlingit master carver Nathan Jackson (fig. 5), the other by his son Stephen Jackson (fig. 6). Both are identified as Grizzly Bear house posts that depict the story of a hunter who married a grizzly bear and eventually was killed. Nathan Jackson's carving depicts a large upright bear holding a black-haired human between its forepaws. Stephen Jackson's work, made of epoxy, includes the ovoids, the *U*-forms, and the swelling and narrowing bands of the formline style that indicate a foundation in Northwest Coast art. But instead of the tightly contained and symmetrical organization of this tradition, Stephen Jackson has pulled elements apart, stretched some to the breaking point, and placed body parts here and there. This dynamic, almost violent image counters the peaceful balance of the father's sculpture.

These two poles are new versions of two older poles that originally stood inside the Teikweidi Bear House in Gaash village, Alaska (fig. 7). Usually four house-posts either support the roof or are attached to support columns and, like exterior totem poles, depict family crests. In 1899 (the same year the Seattle pole was stolen, see pp. 3–5), members of an expedition to Alaska organized by the railroad magnate Edward H. Harriman stopped at Gaash

5 (*top left*) Nathan Jackson (Tlingit), Bear Mother pole. Collection of Burke Museum, University of Washington, 2005. Photo by Aldona Jonaitis, 2010.

6 (*top right*) Stephen Jackson (Tlingit), Bear Mother pole. Collection of Burke Museum, University of Washington, 2005. Photo by Anna Hoover, 2010. Courtesy of Stephen Jackson.

7 (*bottom*) Tlingit, original pole in situ, 1899, inside Teikweidi Bear House, Gaash Village, Cape Fox, Alaska. Photo by C. Hart Merriam. University of Washington Libraries, negative no. NA2136.

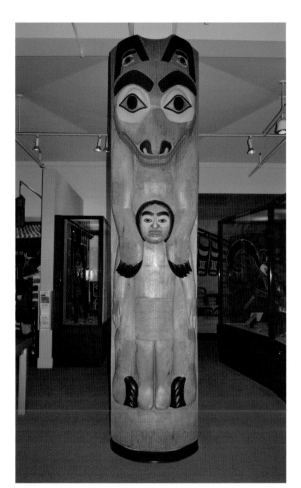

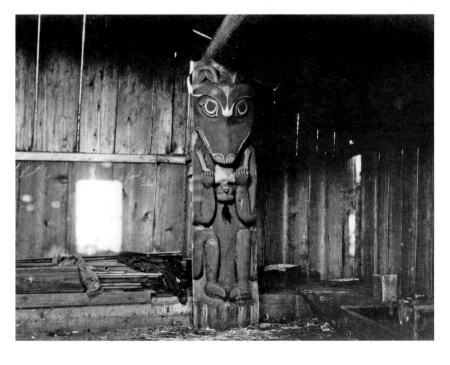

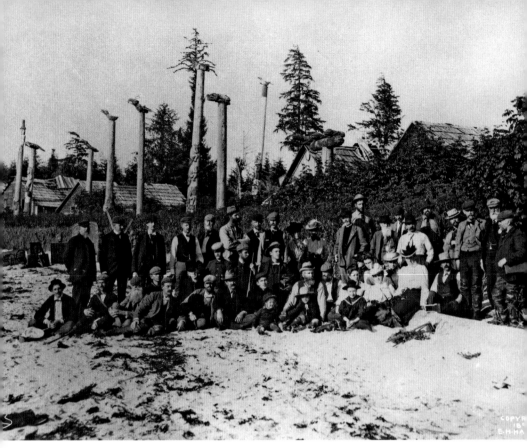

8 Harriman Expedition members on the beach at Cape Fox. Photo by Edward S. Curtis. University of Washington Libraries, negative no. NA2130.

village and, like the Seattle businessmen, removed totem poles from what they decided was an abandoned site (fig. 8). They sent these poles to various museums where they remained for decades; two Bear House poles went to the Burke Museum.

In 1990 the United State Congress passed the Native American Grave Protection and Repatriation Act (NAGPRA), which stipulated that all American museums receiving any federal funds had to inventory their Native American artifacts and human remains and inform Native groups of the materials originating from their communities. The descendants of clans from Gaash were excited when they learned of the museums with the Harriman poles, and requested that they be repatriated. Recognizing that these posts had been stolen, the Burke Museum agreed to send them back to Alaska, and in 2001 the two house posts sailed to Ketchikan on the *Clipper Odyssey*, a small cruise ship that was reenacting the Harriman Expedition. These poles were welcomed by enthusiastic and tearful Tlingit (fig. 9).

To express their appreciation for the return of these treasures, the Tlingit provided cedar logs to the museums that returned the originals so they could have copies made. The Burke hired Nathan and Stephen Jackson to recreate the Teikweidi house posts, which were unveiled in 2005. The father's version

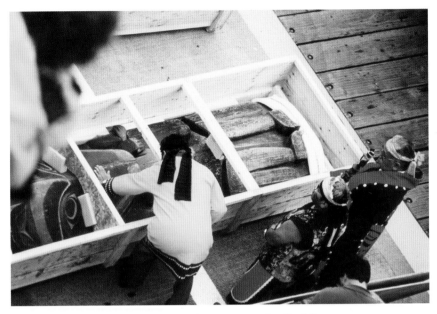

9 Opening of the crate holding the original Bear House poles, Ketchikan. Photo by Robin Wright, 2001.

adheres closely to the original, whereas the son's brings totem pole carving into the twenty-first century. According to the artist, he wanted to demonstrate both the violence of death and destruction inherent in the Grizzly Bear story, as well as the attempted—but ultimately unsuccessful—obliteration of his culture by the forces of colonialism. Thus, in going beyond paying homage to the traditions of his ancestors, Stephen Jackson uses this artwork to make a political statement about how his people have been treated.

Tsaxis
(Fort Rupert)

'Yalis
(Alert Bay)

Port McNeil

Gwa'yasdams (Gilford Island)

KWAKWAKA'WAKW

COAST SALISH

STRAIT OF GEORGIA

NUU-CHAH-NULTH

Vancouver

Musqueam

PACIFIC
OCEAN

Duncan

CANADA

UNITED STAT

Victoria

3 4 5

STRAIT OF JUAN DE FUCA

N

Seattle

50 MILES

50 KILOMETERS

VICTORIA

3 WAWADIT'LA, THE MUNGO MARTIN HOUSE AT THE
ROYAL BRITISH COLUMBIA MUSEUM: END OF THE
CANADIAN ANTI-POTLATCH LAW

During the last decades of the nineteenth century, both the United States
and Canada had almost entirely subjugated the aboriginal owners of those
lands and, in their misguided efforts to "civilize" these people, passed legisla-
tion banning various traditional practices. In 1884, the Canadian govern-
ment passed a law criminalizing potlatches and some related ceremonies; the
Kwakwaka'wakw (previously called the Kwakiutl) disregarded that law and
continued to potlatch openly until 1921, when the Indian Agent W. M. Hal-
liday arrested a number of participants at a major potlatch and sent many to
jail. Although the Kwakwaka'wakw continued to potlatch, they did so furtively.
Potlatches required masks and other regalia, and—throughout the twentieth
century—carvers continued to produce these items, albeit very quietly. One of
the most well-known and well-respected of these artists was Mungo Martin,
whom in 1952 the British Columbia Provincial Museum (now called the Royal
British Columbia Museum) hired to replicate deteriorating totem poles.

As was the case in the United States, the decay of totem poles caused con-
siderable concern and led to government- or museum-sponsored restoration
and replication projects (see pp. 51–53 for other such projects). In addition
to working on poles and conducting public carving demonstrations, Martin
was asked to construct a house of cedar planks for the museum's outdoor
display area, Thunderbird Park. In 1953, Martin built Wawadit'la, a term
that translates as "He orders them to come inside" and that expresses the
considerable power and authority of a chief directing his guests to enter his
house for a potlatch (fig. 10). On its facade, Martin painted the frontal face of
a supernatural sea creature similar to an older version painted on the facade

11

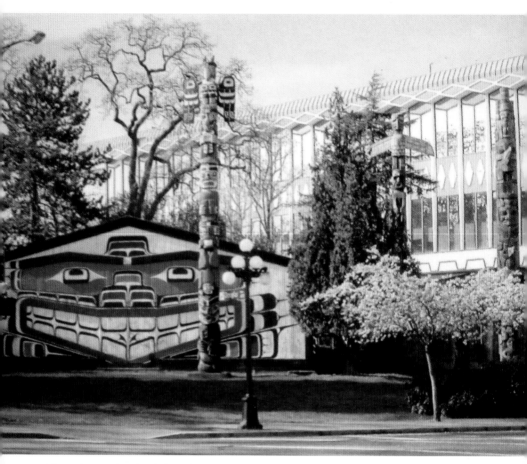

10 Mungo Martin (Kwakwaka'wakw), Wawadit'la house and totem pole, Thunderbird Park, Royal British Columbia Museum, Victoria. Photo by Aaron Glass, 2003.

of the Sea Monster House in Gwa'yasdams on Gilford Island (fig. 11). Martin's family owned the right to display this creature; by illustrating one of his own crests, Martin was able to communicate his high rank in a very public venue. In contrast, the totem pole standing before this house displays crests of four different high-ranking groups, not just Mungo Martin's, and thus expresses the power of the entire Kwakwaka'wakw people.

In 1951 the law prohibiting potlatches was dropped from the Indian Act, thereby, in effect, decriminalized it. This was fortuitous, for Martin wanted to dedicate his house properly, that is, with a potlatch. Thus, the public ceremonial opening of Wawadit'la in 1953 represented the first legal public potlatch that had occurred in British Columbia in almost seventy years (fig. 12). The remarkable masks, impressive dancing, and enthusiastic singing made it very clear—to the museum world, the government, anthropologists, and the public—that potlatching was still a major feature of Kwakwaka'wakw culture.

By 2003, a fiftieth-anniversary potlatch was hosted by Mungo Martin's grandson, Chief Peter Knox, and his wife, Mabel Knox. Their son, artist

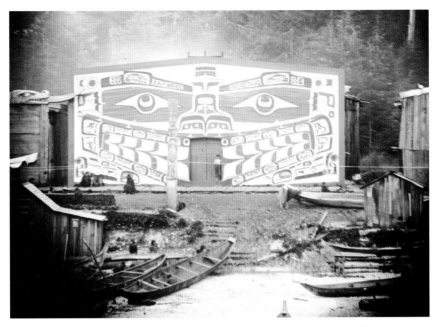

11 Kwakwaka'wakw, Sea Monster House in Gwa'yasdams on Gilford Island. Photo by Charles F. Newcombe, 1900. Royal British Columbia Museum, PN 240.

12 (*left*) Potlatch, Wawadit'la house opening, 1953. British Columbia government photo, British Columbia Archives, I-27009.

13 (*right*) David Knox (Kwakwaka'wakw) renewing the painted design on Wawadit'la house, 2003.

David Knox, restored his great-grandfather's dramatic painting (fig. 13). Today, with the permission of Chief Knox, who owns the rights to it, the house can be used for ceremonies. This demonstrates how deeply ingrained in the Kwakwaka'wakw sense of identity is the ownership of privileges, both tangible—like the images on the house—as well as intangible, such as possessing the right to allow others to use the facility. Wawadit'la, therefore, is not simply a museum artifact, but an integral part of a living family tradition that remains strong in the twenty-first century.

4 SGAANG GWAII (NINSTINTS) POLES AT THE ROYAL BRITISH COLUMBIA MUSEUM: THE NOT QUITE DISAPPEARING HAIDA

In 1956, a visionary British Columbian anthropologist by the name of Wilson Duff traveled to the remote, uninhabited community of Sgaang Gwaii (Ninstints) on the farthest southern tip of Haida Gwaii, where an impressive stand of thirty totem poles still stood (fig. 14). In the late nineteenth century, missionaries and government officials encouraged the Haida to stop carving poles and to cease all traditional ceremonies like potlatches. By the mid-twentieth century, it was becoming recognized that such encouragement—at times accompanied by coercion or even force—was part of a larger attempt at cultural destruction that bordered on cultural genocide. In part to correct such past injustice and to preserve what had been almost entirely destroyed, Duff and his colleagues wanted to salvage these magnificent carvings, such as the totem poles of Sgaang Gwaii.

Duff had to obtain permission for this from the descendants of Sgaang

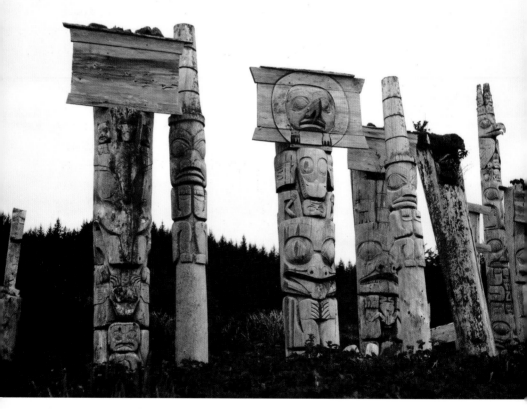

14 Sgaang Gwaii, 1901. Photo by Charles F. Newcombe.
British Columbia Archives, AA-00156.

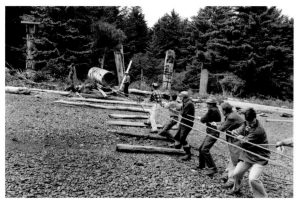

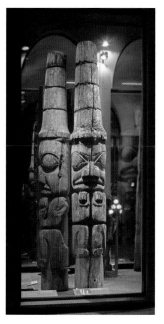

15 (*top left*) Haida, Sgaang Gwaii, removal of a memorial pole, 1957. British Columbia Archives, I-28962.

16 (*top right*) Sgaang Gwaii, pulling a pole to the beach, 1957. British Columbia Archives, I-28963.

17 (*bottom*) Haida memorial poles, Sgaang Gwaii. Royal British Columbia Museum, 15558a, 15558b.

Gwaii families who in the nineteenth century had moved north to Skidegate. In 1957 Duff met with these descendants and discussed bringing some poles to the Museum of Anthropology in Vancouver and the Royal British Columbia Museum in Victoria. In return, each pole owner would receive $50 for each section of pole removed. They agreed, and Duff returned to Sgaang Gwaii with anthropologists, Haida artist Bill Reid, a film crew, and several Haida assistants.

The group identified, took down, and crated eleven poles, and then by motorboat towed them out to be winched onto the deck of a ship borrowed from the Navy for this purpose (figs. 15, 16). The ship sailed south to Victoria, where the poles destined for the museum in that city were unloaded and placed in a warehouse to dry. The Royal British Columbia Museum later conserved the poles, two of which are erected at its east entrance (fig. 17). The others went on to Vancouver.

Two years later, the Canadian Broadcasting Company produced *Totem*, a film about this salvage expedition. Bill Reid, who was already a well-known CBC announcer, narrated the film, which was a poetic lament on the death of this village. His words conveyed its scope and finality: "Think also of what had been lost; not only the poles and other material things that had been destroyed . . . but all the rich pattern of legend and ceremony

that lay behind these massive expressions of a rich and powerful way of life" (quoted in Jonaitis and Glass, 2010, 176–17).

It is both ironic and heartening that this destruction was not as complete as Reid suggested. Yes, the poles at Sgaang Gwaii were certainly deteriorating, and the town was devoid of human life. But that was not the end. In 1980, Sgaang Gwaii was named a UNESCO World Heritage Site, a designation that ensures its continued protection. And, even more important, in 1981 the Haida formed the Haida Watchman Program, named after the three small squatting figures wearing tall hats perched atop many poles, who are said to warn the village of approaching enemies. Resident Watchmen stay at Sgaang Gwaii and several other village sites from May to September, welcome visitors, ensure they have already obtained official Haida permission to enter the site, and then conduct a guided tour. In this way, the Haida exert control over their heritage, and convey to all that they are still a powerful people with a thriving culture.

5 TONY HUNT'S GRIZZLY BEAR AND HUMAN POST AT HORSESHOE BAY: THE TOTEM POLE AS THE SYMBOL OF BRITISH COLUMBIA

Totem poles have been appropriated by non-Natives for all sorts of reasons. In Seattle, a Tlingit pole from Tongass became the symbol of that city (pp. 3–5). In the twentieth century, poles became symbolic of British Columbia. The 1958 centennial celebrations of British Columbia becoming a crown colony produced postcards saying "Klo-how-ya (Hello) from Totem Pole Land." *Maclean's* magazine centennial publication included an advertisement for the Bank of Montreal depicting one of the "twentieth century totems . . . symbols of British Columbia's Century of Progress," a pole composed of a miner carrying a remarkably phallic drill, a lumberman carrying a chainsaw and, instead of Thunderbird with outstretched wings, an airplane (fig. 18). Eight years later, the province celebrated the centennial of uniting Vancouver Island and the British Columbia mainland into a single colony. At the 1966 Tournament of Roses Parade in Pasadena, California, British Columbia's centennial float, which featured two winged totem poles, one upright and the other at a rakish angle, won the International Trophy (fig. 19).

During the years that separated these two centennials, official policy became significantly more respectful toward the First Nations of British Columbia. In 1958, marketers simply appropriated the image of the totem pole for whatever they wanted. While such behavior continued (as it still does to this day), for the 1966 centennial the province chose to celebrate the

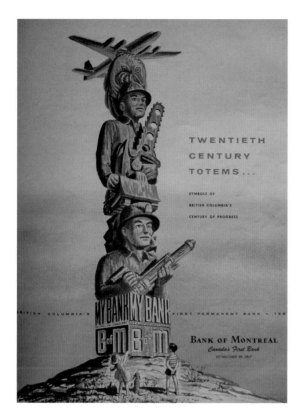

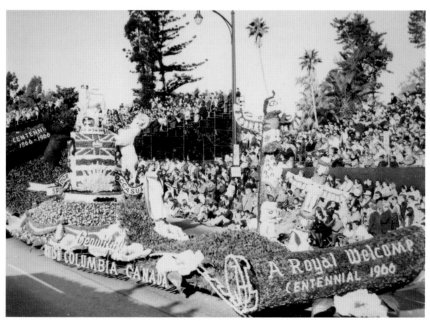

19 British Columbia float, Pasadena Tournament of Roses Parade, 1966.
Courtesy of Pasadena Tournament of Roses Archive.

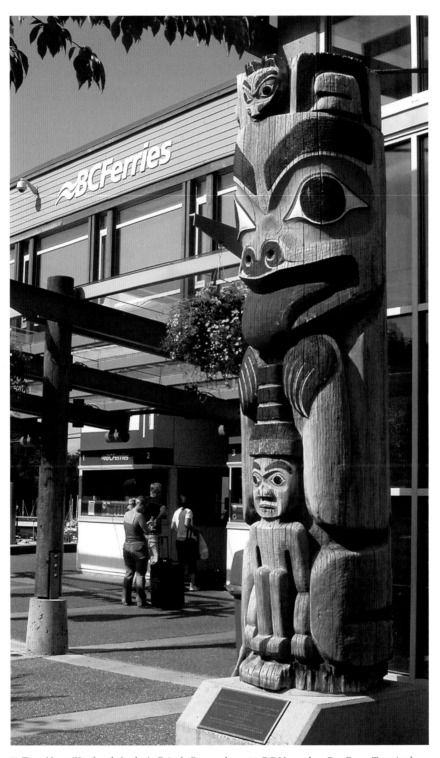

20 Tony Hunt (Kwakwaka'wakw), Grizzly Bear pole, 1966. BC Horseshoe Bay Ferry Terminal. Photo by Aaron Glass, 2003.

vitality of contemporary Native culture. A project was initiated that funded the carving of new poles to be placed along roads and at ferry terminals to designate "The Route of the Totems." Tourism was to be a major contributor to the province's economic development, and how better to promote travel than with the most popular image of the region?

Native artists were invited to submit designs for carvings that would be twelve feet high by three and a half feet wide and depict a grizzly bear at the base. The artist could be creative and original within these parameters. Evaluating the proposals were anthropologist Wilson Duff and Nuu-chah-nulth artist and writer George Clutesi; winners of the commission received $750 while those rejected received $250 for their efforts. Ultimately, twelve poles marked the travelers' route from Victoria to Vancouver to Prince Rupert, indelibly bonding the totem pole with British Columbia tourism.

Near the BC Ferries terminal at Horseshoe Bay stands one of these Route of the Totems poles, carved by Kwakwaka'wakw Tony Hunt (fig. 20). Hunt is the son of master carver Henry Hunt and worked with Mungo Martin in restoring totem poles at the Royal British Columbia Museum. The extended Hunt family includes many artists such as Tony and his brother Richard, Tony Hunt Jr., Doug Cranmer, Calvin Hunt, and Kevin Cranmer. The Hunt family legacy is impressive; today totem poles by members of this distinguished family of artists can be found not only in Canada but in the United States, Europe, Asia, and Australia.

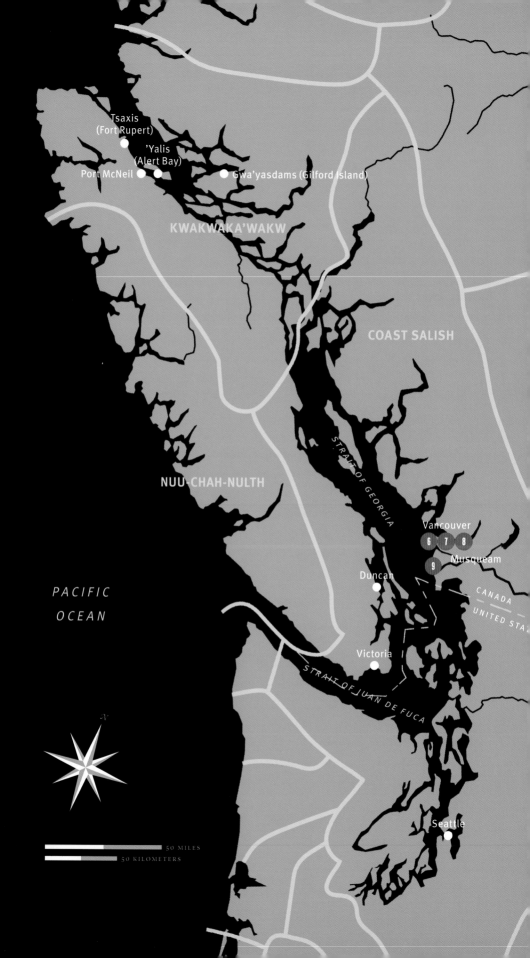

VANCOUVER

6 HAESEMHLIYAWN MEMORIAL TOTEM POLE OF
THE GITK'SAN FROM GITANYOW (KITWANCOOL)
AT THE MUSEUM OF ANTHROPOLOGY: POLES,
POLITICS, AND THE WORK OF MUSEUMS

The fortunate driver who takes Highway 16 from central British Columbia
down along the Skeena River to Prince Rupert sees not only incredible scen-
ery but several communities with impressive totem poles. The Gitk'san of
this area are a powerful people who over the years petitioned for legal owner-
ship of their lands. Gitanyow, formerly called Kitwancool, was home to some
of the most exquisitely carved poles and politically active chiefs (fig. 21).

In 1952, Wilson Duff, who a few years later worked to retrieve poles from
Sgaang Gwaii in Haida Gwaii (see pp. 14–15), was deeply impressed with
the totem poles of the Gitk'san. He estimated that about fifty old poles were
worth salvaging, but knew these people would be unwilling to part with their
treasures—they had had unpleasant experiences with government officials
and wanted nothing to do with someone who, like Duff, worked for the Prov-
ince. But Duff was indomitable. He also believed that the poles of Gitanyow
were the finest in existence and wanted them saved before they completely
decomposed. When he approached the chiefs of that village, they absolutely
refused—but not, as one might expect, on cultural or artistic grounds, but
rather for political reasons.

The chiefs had for decades unsuccessfully argued with the government
to gain legal title to their land. Originally, totem poles served as statements
of family history and worth, directed toward members of their larger com-
munity. However, over the years, the meaning of the poles in Gitanyow and
other villages subtly changed to collective statements, directed more toward
non-Natives, that "this land these poles stand upon is Gitk'san." Nothing was

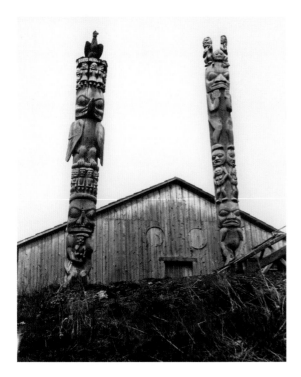

21 Gitk'san, Gitanyow, 1910. Photo by George Emmons. University of Washington Libraries, negative no. NA3480.

important enough to convince the Gitanyow chiefs to allow some outsider to take these carved monuments of sovereignty.

Duff, never accepting defeat, returned to Gitanyow in 1958, proposing that the Royal British Columbia Museum would collect the originals of the poles he most wanted, and then have copies made. These reproductions would be sent to the village where they would be erected, at the museum's expense. The chiefs were interested in this idea, but added a stipulation: in return for the old poles, the museum would not only make replicas, it would sponsor the research, writing, and publication of a Gitanyow history that demonstrated without question their ownership of this land. An agreement to this effect was drafted and signed.

The copies made in Victoria were sent north and erected in Gitanyow where they can still be seen (fig. 22). One of the old poles stands today in the Great Hall of the Museum of Anthropology on the University of British Columbia campus (fig. 23). To complete the agreement, in 1958 the museum in Victoria published *Histories, Territories, and Laws of the Kitwancool*, edited by Wilson Duff, and, as had also been stipulated earlier, sent enough copies to the University of British Columbia so that students and professors alike would be able to learn about the Gitanyow and understand their position on their land. This historic book is still in print, another part of the agreement made more than fifty years ago.

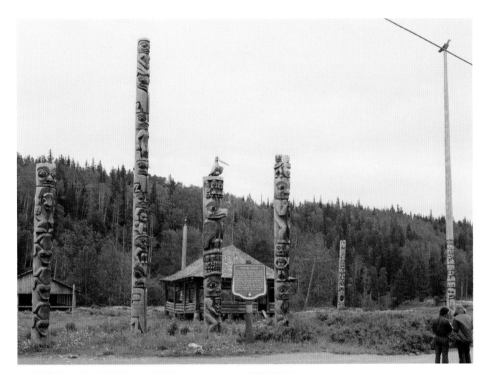

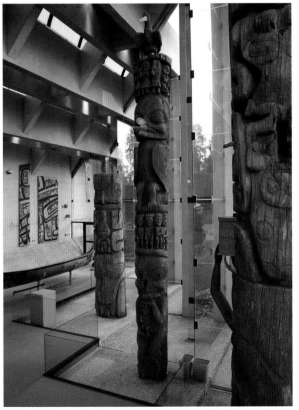

22 Gitanyow replicated totem poles, 1961. British Columbia Archives, PN 12985–3.

23 Gitanyow memorial totem pole. Museum of Anthropology, Vancouver, A50019. Photo by Jessica Bushey, 2010.

MONUMENTS BY BILL REID, DOUG CRANMER, AND JIM HART AT THE MUSEUM OF ANTHROPOLOGY: THE TOTEM POLE BECOMES ART

Not so long ago, it was thought that Northwest Coast art—and aboriginal art worldwide—should be exhibited in natural history museums, not art galleries. Thus, the best collections of these materials in the United States are at the American Museum of Natural History in New York, the Field Museum in Chicago, and the Smithsonian's National Museum of Natural History in Washington, DC. In Canada, they stand not only in institutions such as the Royal Ontario Museum and the Royal British Columbia Museum, but also in history and anthropology museums such as the Canadian Museum of Civilization, and the Museum of Anthropology in Vancouver. Before the 1960s, very few art museums exhibited Native art; the Denver Art Museum is one of only a few major institutions that displayed their fine collections before mid-century. Much of the time Native creations were not even referred to as art, but as ethnographic artifacts, and, in an outdated concept of cultural evolutionism, anyone who did consider the work artistic was reminded that it was simply inferior to the art of the civilized West. Today, Northwest Coast art appears in numerous art museums, including the Seattle Art Museum, the National Gallery of Canada, the Minneapolis Institute of Arts, and the Metropolitan Museum of Art in New York City.

The reasons for this transformation of Native creations from artifact to art are many, including the more liberal and tolerant attitudes about race and ethnicity that emerged in the 1960s. One man who contributed greatly to the new realization that Northwest Coast objects had to be accepted not simply as artifacts but as artworks was Bill Reid, a man of Haida ancestry who was both an articulate and poetic spokesperson for this tradition as well as a universally recognized master artist. Reid worked at the Museum of Anthropology (MOA) on the University of British Columbia campus, creating totem poles, carvings, and Haida houses that came to be praised as artworks of the highest order.

It was most appropriate that Reid created art at MOA, for if there is such a thing as a temple for totem poles, it would be this museum. After entering the building, the visitor walks down a sculpture-flanked ramp into the huge, glass-enclosed Great Hall in which totem poles stand, flooded by natural light. Looking through the windows one can see more poles outside and—beyond them—the mountains and blue waters of the Strait of Georgia. The grandeur, the monumentality, and the transparent walls that unite the magnificence of these carvings with the stunning surroundings all contribute to a transcendent, perhaps even spiritual experience. These qualities were, of

course, the intention of the architect Arthur Erikson, who wanted this Great Hall to be like a cathedral.

Some poles that stand here are old, nineteenth-century pieces, such as the Gitanyow pole discussed on pp. 22–23, along with some Haida poles retrieved by Wilson Duff (see pp. 14–16), lovingly conserved and maintained by the highly trained professional staff. The poles outside on the grounds, as well as two plank houses, are considerably newer and thus able to tolerate the elements, at least for a period of time.

Bill Reid was raised in the non-Native world, even though his mother was Haida. He became increasingly interested in his heritage, especially after he helped Wilson Duff retrieve decaying Haida masterpieces at Sgaang Gwaii (see pp. 15–16). By studying art in books and museum collections, Reid—who had been a practicing jewelry maker—taught himself to carve in his ancestral style. In 1958, Wilson Duff hired Reid, along with master Kwakwaka'wakw carver Doug Cranmer, to replicate some of the museum's Haida poles. Ultimately, they not only carved six new poles, they also built a small mortuary house and, next to it, a full-size plank house (fig. 24). The pole standing before the mortuary structure was a smaller scale version of a pole that had smitten Reid in Sgaang Gwaii. The pole in front of the full-size house was copied from one collected at Skidegate (fig. 25).

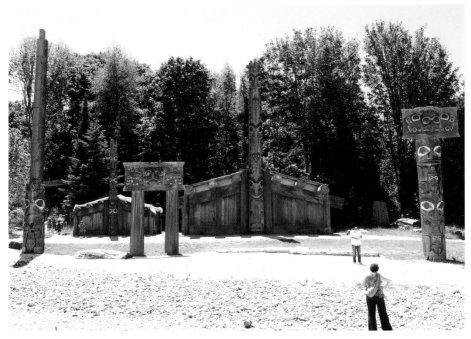

24 Doug Cranmer (Kwakwaka'wakw), Bill Reid (Haida), and Jim Hart (Haida), Haida houses and poles, 1958–1962, 2000. Photo by Aaron Glass, 2007.

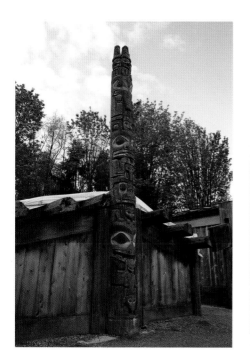
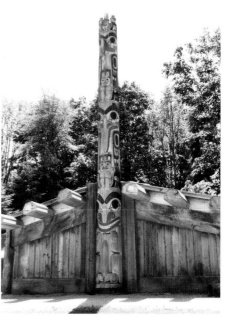

25 (*left*) Doug Cranmer (Kwakwaka'wakw) and Bill Reid (Haida), Haida house frontal pole, 1958–1962. University of British Columbia, Museum of Anthropology, A50033. Photo by Jessica Bushey.

26 (*right*) Jim Hart (Haida), Respect to Bill Reid pole, 2000. Photo by Aaron Glass, 2010.

By the 1990s, the Skidegate copy, having deteriorated beyond salvage, was brought inside and placed in the Great Hall. As Bill Reid, then seriously ill with Parkinson's Disease, was unable to carve a new version, the museum commissioned Haida master Jim Hart to create what is known as the *Respect to Bill Reid* pole (fig. 26). Raised on October 1, 2000, to a celebration of 2,500 people, this pole now stands before the plank house made forty years before. The original of this pole stood in Skidegate before the house of a chief. The second version, carved lovingly by a man dazzled by the original's artistry, itself became regarded as an important work of art. And the third version that honors the second version's creator brings Haida totem pole *art* into the twenty-first century.

8 THE THUNDERBIRD HOUSE POST BY TONY HUNT AT STANLEY PARK: THE IRRESISTIBLE ATTRACTION OF POLES WITH WINGS

If you wander into any tourist shop in Alaska or British Columbia, you'll doubtless see a totem-pole souvenir with a crouching bear on the bottom and a spread-winged Thunderbird on top. The same pole appears on innumerable Alaska mementos, including playing cards, refrigerator magnets, and bottle openers (fig. 27). This, the most popular and frequently reproduced totem-

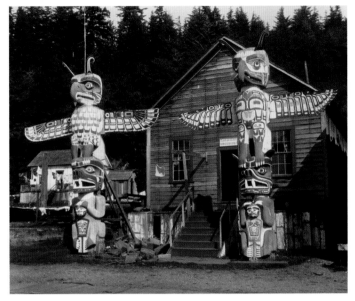

27 (*left*) Thunderbird pole bottle opener. Jonaitis collection, 2010.

28 (*right*) Kwakwaka'wakw, Chief Thah-Co-Glass house posts, Alert Bay, 1909. Photo by John Cobb. University of Washington Libraries, negative no. NA2767.

pole image, is based upon four house-posts carved at the turn of the twentieth century. Despite the fact that they are considered iconically Alaskan, these poles were made by the Kwakwaka'wakw of British Columbia.

Of the four original Thunderbird House Posts, two were carved for the interior of a house in Alert Bay but ended up in the street outside a house (fig. 28). These eventually disintegrated, and today the decayed remains of one of the poles stands near the U'mista Cultural Centre (fig. 29). Master carver Charlie James made the other two for a chief who lived in Kingcome village. For some reason these were never erected in his house, but instead went to Fort Rupert to be used in the 1914 Edward S. Curtis film *In the Land of the Head Hunters* (later renamed *In the Land of the War Canoes*) (fig. 30). Curtis hoped that this movie, a boy-meets-girl, boy-loses-girl, boy-gets-girl-back story filmed in a re-created prehistoric village with Kwakwaka'wakw actors and actresses, would become a commercial success. Unfortunately, it did not.

The Art, Historical and Scientific Association of Vancouver, a group assembled in 1924, decided that an "Indian village" should be built in Stanley Park. To begin this project, they purchased Charlie James's two house posts as well as another Alert Bay pole. The planned houses were never built, but over the years as more and more poles were obtained the current assemblage of totem poles in Stanley Park was created (fig. 31).

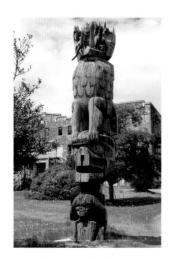
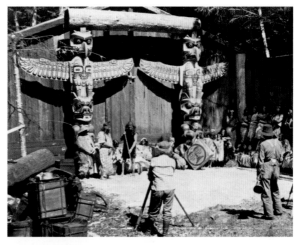
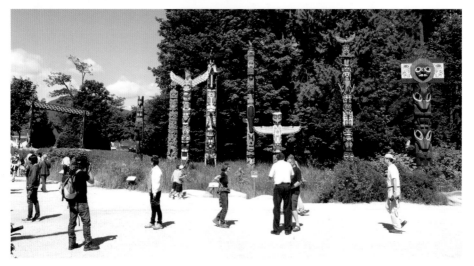

29 (*top left*) Kwakwaka'wakw, Chief Thah-Co-Glass house posts, Alert Bay.
Photo by Aaron Glass, 2010.

30 (*top right*) Charlie James (Kwakwaka'wakw), Thunderbird house posts in a scene from
Edward S. Curtis's film *In the Land of the Head Hunters*. Curtis is standing at the tripod to the
left. Photo by Edmund August Schwinke, 1914. Burke Museum of Natural History and Culture,
ethnology archives.

31 (*bottom*) Stanley Park totem poles. Photo by Aaron Glass, 2010.

Like so many other historic poles left to the elements, one of the Thunder-
bird posts had so deteriorated by 1968 that it was moved into the Vancouver
Museum. A fiberglass cast of this pole was made and placed near a miniature
railroad in Stanley Park. One wonders what Charlie James would think of his
exquisite house-post being transformed into a full-sized fiberglass plaything.
In 1986, the other pole had to be taken indoors as well. Tony Hunt, assisted
by John Livingston, Tony Hunt Jr., and Phil Nuytten, made the present replica
that today stands in Stanley Park (fig. 32).

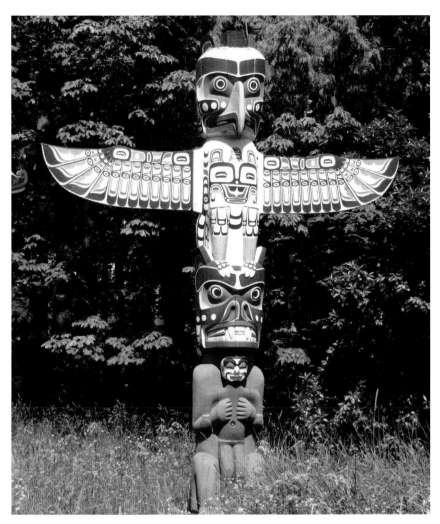

32 Tony Hunt (Kwakwaka'wakw), Thunderbird pole, Stanley Park, Vancouver, 1986.
Photo by Aaron Glass, 2010.

Why has this particular pole become so popular? Traveling on the North-
west Coast, you will see it all over the place—on postcards, in advertisements
for all sorts of things, even on paper place mats in diners. It is a testament
to its attractiveness that Alaska appropriated it as its own totemic symbol.
But why this particular pole, which is not that common when compared
with hundreds of wingless poles? While there is no conclusive answer to this
question, it is possible that the outstretched wings mounted on an upright
post suggest the Christian cross. Many people feel uncomfortable with the
exotic and unfamiliar. Perhaps the similarity between an alien image and a
universally understood symbol makes the Native design feel more familiar,
and therefore more sympathetic.

9 CARVINGS BY SUSAN POINT, JOE DAVID, AND DON YEOMANS AT VANCOUVER INTERNATIONAL AIRPORT: POLES AS POLITICS AT AN INTERNATIONAL AIRPORT

The totem pole, appropriated as a symbol of British Columbia since before its centennial celebrations (pp. 16–19), continues to play an important role defining the province's character and heritage. In that spirit, in 1994 the Vancouver International Airport (YVR) established the YVR Art Foundation to encourage display of First Nations art in the airport. As you descend the escalator leading into the baggage claim area in the International Arrivals Building of the airport, two tall, powerfully carved figures by Musqueam Salish artist Susan Point greet you (fig. 33). And, as you exit, two more welcome figures reach their hands out to you, these by Nuu-chah-nulth artist Joe David (fig. 34). It is appropriate that these two artists welcome the newcomer, for they represent the aboriginal groups of the region.

These carvings embody political messages. For example, Susan Point's welcome figures make two interrelated statements about the strength of the Musqueam and their culture. Coast Salish speaking people, of which the Musqueam are one group, were the original inhabitants of the region that includes Vancouver, Victoria, and Seattle, and were thus the first Northwest Coast Native people to have their lands appropriated by settlers. In recent years, the Coast Salish of British Columbia, like many Native groups in the

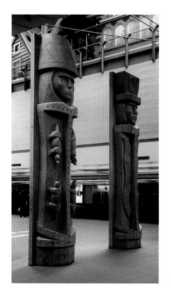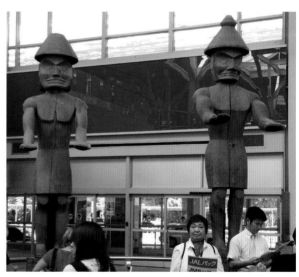

33 (*left*) Susan Point (Musqueam Salish), male and female ancestor welcome figures. Vancouver International Airport International Arrivals Building, 1996. Photo by David Jensen, courtesy of Susan Point.

34 (*right*) Joe David (Nuu-chah-nulth), welcome figures, Vancouver International Arrivals Building, 1986. Photo by Aaron Glass, 2010.

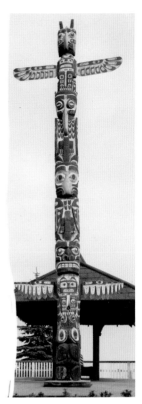

35 (*left*) Musqueam house posts, 1915. Photo by Charles F. Newcombe. British Columbia Archives, CA AA-00235.

36 (*right*) Chief Mathias Joe Capilano (Squamish Salish), Stanley Park pole, 1936. City of Vancouver Archives, P192.1N103.1.

province, have fought for sovereignty over their land. Musqueam territory in fact includes the site of the Vancouver Airport, so Susan Point's figures welcome visitors not just to British Columbia and Canada, but specifically to *Musqueam* land.

The other statement about Musqueam culture these figures make concerns the nature of Salish art. Compared with the more ornate art of the people to their north, with its ostentatious show of crest privileges, Salish art is more private in its display and stylistically simpler, with less complex decorated surfaces (fig. 35). Perhaps because this style is comparatively understated, Salish art has, over the years, been neglected in favor of other Northwest Coast styles. In 1936, for example, when the Salish Chief Mathias Joe Capilano of the Squamish band wanted to erect a pole in Stanley Park to assert his people's claim on this land, he chose to make not a Salish-style work but instead a Kwakwaka'wakw-style pole surmounted by a spread-winged Thunderbird (fig. 36). Today, when one finds totem poles in Vancouver, Victoria, and Seattle, almost none are in the style of that region's first people. Susan Point's welcome figures, carved in her

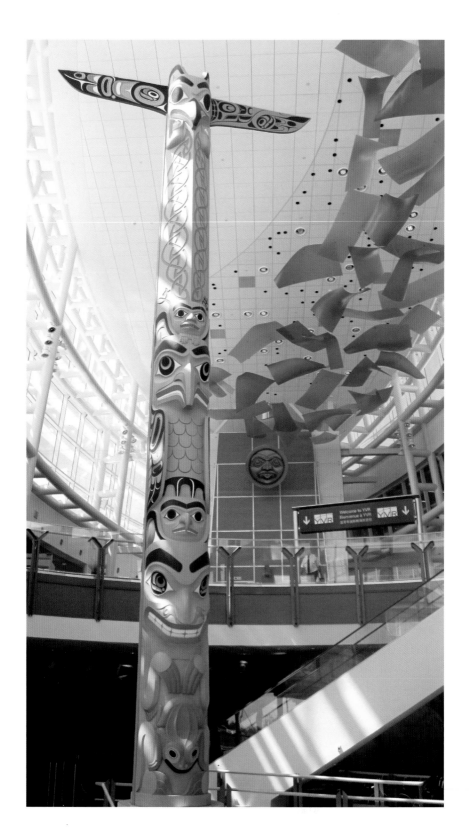

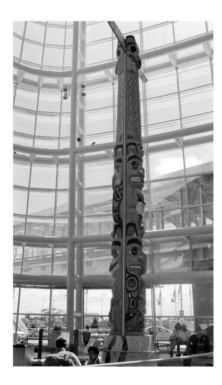

traditional style, are a conscious statement of the vitality and resurgence of *Salish* style art in Salish land.

Another pole in the Vancouver Airport, located in the Link Building, communicates a significantly different message (figs. 37a, b). The Haida artist Don Yeomans carved his pole, *Celebrating Flight*, to acknowledge that all humans, although not able to fly by themselves like birds, have through their innate intellectual capacities developed the technology to do so. Flying has brought the world's peoples far closer together, and—in reference to contemporary globalism—Yeomans depicts not only Haida crest images but also Celtic knot-work and the Chinese symbols for heaven, earth, pride, and civilization. These images from three continents communicate the nature of the airport as an international crossroads. The pole itself is one part of Yeomans's installation, with its mosaic floor representing water, and the aurora of floating blue and green light panels overhead leading to a carving of the moon. Bringing this pole into the twenty-first century by including new technology, Yeomans inserted a bright green LED strip of light that separates the pole's front and back. This innovative totem pole has transcended the confines of purely First Nations significance to express a universal statement of pride in human accomplishment.

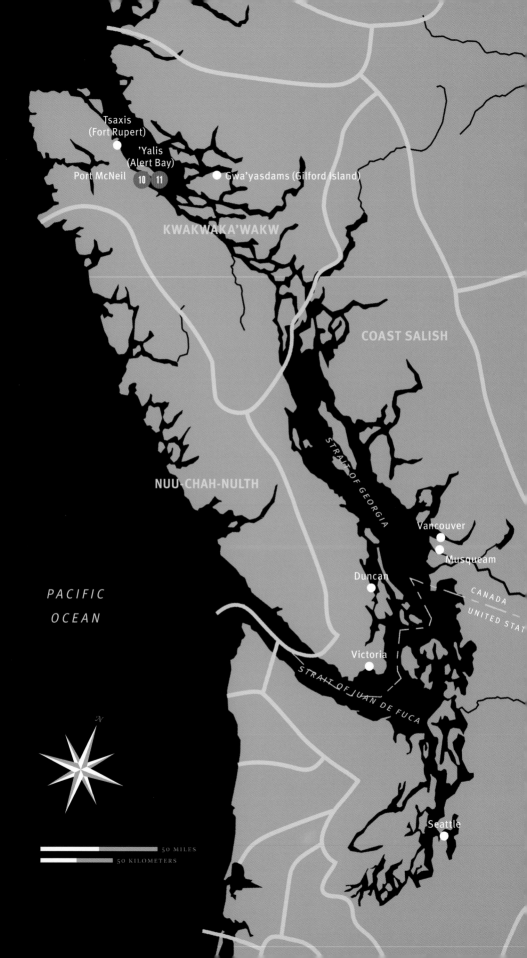

Tsaxis
(Fort Rupert)

'Yalis
(Alert Bay)

Port McNeil 10 11

Gwa'yasdams (Gilford Island)

KWAKWAKA'WAKW

COAST SALISH

NUU-CHAH-NULTH

STRAIT OF GEORGIA

Vancouver

Musqueam

Duncan

CANADA
UNITED STAT

PACIFIC
OCEAN

Victoria

STRAIT OF JUAN DE FUCA

N

Seattle

50 MILES
50 KILOMETERS

VANCOUVER ISLAND

10 THE WORLD'S TALLEST POLE AT ALERT BAY:
TALLNESS AS A TOURISTIC ATTRACTION

To get to Alert Bay, you drive north of Victoria on the road that hugs the east coast of Vancouver Island. The totem pole aficionado will likely first stop at Duncan, the self-designated "City of Totems" that in 1986, as part of an effort to get tourists to visit the town on their way north, installed poles along the main road. When Richard Hunt's Cedar Man pole was erected in Duncan in 1988, the work—carved from a tree of immense width—became known as "the world's widest totem pole" (fig. 38). Continuing the trip, you drive several hundred kilometers to Port McNeil, then take a forty-five-minute ferry ride. As you approach Alert Bay, you will see a good number of poles in the Native cemetery (see pp. 39–40). And if you look to the top of the hill, you'll see a very thin, very tall pole that may or may not contain totem images—it is just too far away to tell. Not only is it indeed a

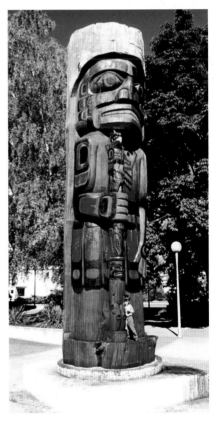

38 Richard Hunt (Kwakwaka'wakw), Cedar Man pole, 1988, Duncan. Photo courtesy of Richard Hunt.

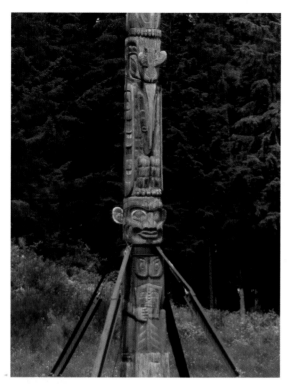

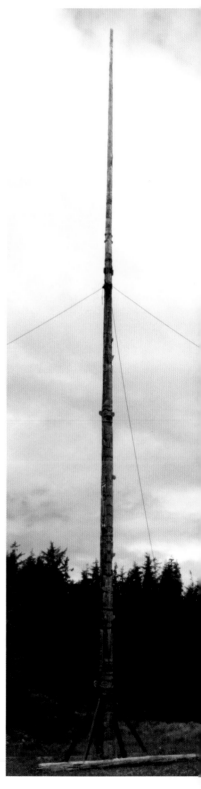

39A, B James Dick, Benjamin Adam, Gordon Matalpi, and Mrs. Billy Cook (Kwakwaka'wakw), "Tallest Totem pole," 1973; and Big House, facade designed by Doug Cranmer (Kwakwaka'wakw), 1999, Alert Bay. Photos by Aaron Glass, 2010.

totem pole, at 173 feet, it is identified in the tourist literature as the "world's *tallest* totem pole." In 1973, James Dick, Benjamin Adam, Gordon Matalpi, and Mrs. Billy Cook carved this pole, portraying thirteen figures, each representing one of the Kwakwaka'wakw bands, to stand near the Alert Bay big house that had been opened in 1965 (fig. 39a). In order to achieve this height, they had to attach two logs together; then they stabilized the raised pole with guy ropes and propped it up at the bottom with steel (fig. 39b).

The notion of the "world's widest" or "world's tallest" totem pole would have been meaningless to the original totem pole carvers. No individual totem pole was in competition with other poles;

each one represented a unique family legacy. In some communities, the tallest pole might have been owned by the highest-ranking chief, but that was by no means a universal rule. So where did this notion of the importance of the widest and tallest totem poles come from?

Tourism. This 173-foot pole was erected in Alert Bay specifically to attract tourists, as tourists often seek out the biggest, tallest, widest (or other similar superlatives) among the attractions as they travel. Think of the largest ball of twine in Darwin, Minnesota; the tallest water slide in Rio de Janeiro, Brazil; or any of the other myriad tallest, largest, and fattest records listed in the Guinness Book of World Records.

The Alert Bay monument is not the only pole with a claim to being the tallest. In 1956, the *Victoria Times* devised a fund-raising scheme in which, for a share of 50 cents, an individual could view a pole being carved by Kwakwaka'wakw master Mungo Martin, and have his or her name added to a scroll buried under the pole. More than 10,000 shares were sold, and the original 127 foot 7 inch pole was erected in Victoria's Beacon Park; what you see there today is a restoration that was done in 2001.

Other tallest poles were carved later. Don Lelooska, a Cherokee artist trained in the Northwest Coast style, made a 140-foot pole for Kalama, Washington, where it is used as a tourist draw. In 1969, Alaska Indian Arts, a non-Native-owned operation that trained and hired Native artists, carved a 132 foot 5 inch pole that was raised in Kake and also serves to attract visitors. Then in 1994, when the Commonwealth Games were held in Victoria, Art Sterritt, Bill and Alex Helin, Richard Krenz, Jessel Bolton, Heber Reese, and Nancy and Anthony Dawson worked together to carve a 180 foot 3 inch pole that stood in Victoria's Inner Harbour. It was so tall that

the city officials insisted that it have a blinking light on top to alert landing sea planes and steel brackets that anchored it to the ground with guy-wires. Although there was no question this was *the* tallest pole on the coast, the city became nervous about its height and demanded that it be shortened dramatically. So no longer is it the tallest.

And what about the others? The Lelooska pole was made by a non-Northwest Coast carver, so is it a legitimate Northwest Coast totem pole? And the Alert Bay pole is made from two logs, so can it really be thought of as the tallest? The Kake pole qualifies as the tallest pole in Alaska, but not the world. So probably Mungo Martin's 1956 pole still holds the record.

But then we must ask ourselves: "So what?"

11 THE POLES IN ALERT BAY:
CEMETERIES AND SOVEREIGNTY

In 1897, the world traveler Eliza Scidmore wrote in her *Appleton's Guidebook to Alaska and the Northwest Coast* that at Alert Bay one could see "the most southerly totem pole and the only one known to have been erected on the coast within ten years" (Scidmore, 1897, 22) (fig. 40). Her comment that "missionaries have not been able to do anything with these people" pertains to how resolutely the Kwakwaka'wakw clung to their ceremonial traditions, continuing actively to potlatch despite a law prohibiting it and raising new totem poles when almost all other groups on the coast had ceased doing so.

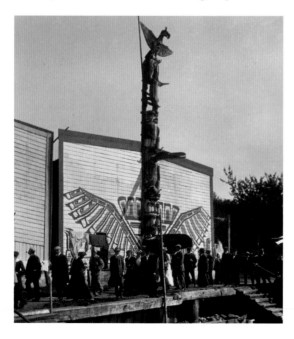

40 Kwakwaka'wakw, Alert Bay, Wakius house and totem pole with tourists, 1909. Photo by John. N. Cobb. University of Washington Libraries, negative no. NA2760.

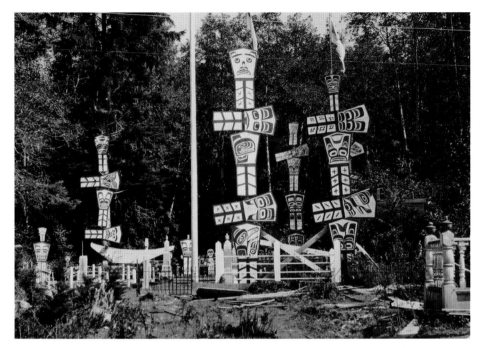

41 Alert Bay, Native cemetery, ca. 1915. University of Washington Libraries, negative no. 2968.

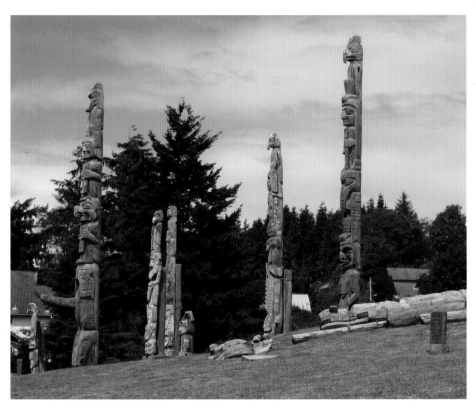

42 Alert Bay, Native cemetery. Photo by Aaron Glass, 2010.

And in a particular taunting of the officials who viewed them as "the incorrigible Kwakiutl," for a fee they would even perform masked dances for visitors.

In addition to carvings erected in front of their houses, residents of Alert Bay continued to include traditional crest images in their cemeteries. The tallest memorials (fig. 41) were composed of wooden replicas of coppers, which are shield-shaped plaques of beaten copper that embody immense wealth. Today, memorial poles stand together in the burial ground (fig. 42). Often, the owners do not replace damaged poles, believing that a memorial does not last forever and thus should not be salvaged; if desired, a new pole can be erected. This is certainly a different attitude from that of the preservationists so abundant in museums and among the general non-Native public!

Decades ago, a road was built that ran between the burial ground and the water; that road ran over some of the graves that were close to the shore. In the mid-1990s, the Kwakwaka'wakw leadership managed to convince the city council to push the road back fifteen feet closer to the water. This extended the road over the high-tide line, necessitating a new concrete barrier. Rerouting the road was considered a major Kwakwaka'wakw victory and an expression of an increasingly powerful political voice.

Visitors to Alert Bay are welcome to photograph the array of poles in what is labeled the 'Namgis Burial Ground, named after the Kwakwaka'wakw band whose lands these are. However, a sign near a Thunderbird pole expli-

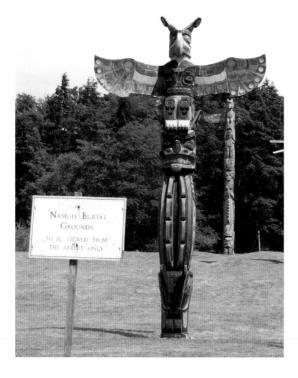

43 Don Svanvik, Bert Svanvik, Sean Whonnock, and Jonathan Henderson (Kwakwaka'wakw), Memorial for Great-Grandparents John and Mary Whonnock, 2004. Photo by Aaron Glass, 2010.

citly states that it "be viewed from the street only"; people are *not* welcome to wander around the site (fig. 43). Once again, a Native community is asserting its rights over its own heritage. How much has changed in a century. When tourists visited at the turn of the century, they would have had no compunction about entering houses uninvited; in the words of Eliza Scidmore, they would have "scrutinized and turned over everything they saw with an effrontery that would be resented, if indulged in kind by the Indians" (Scidmore 1885, 60).

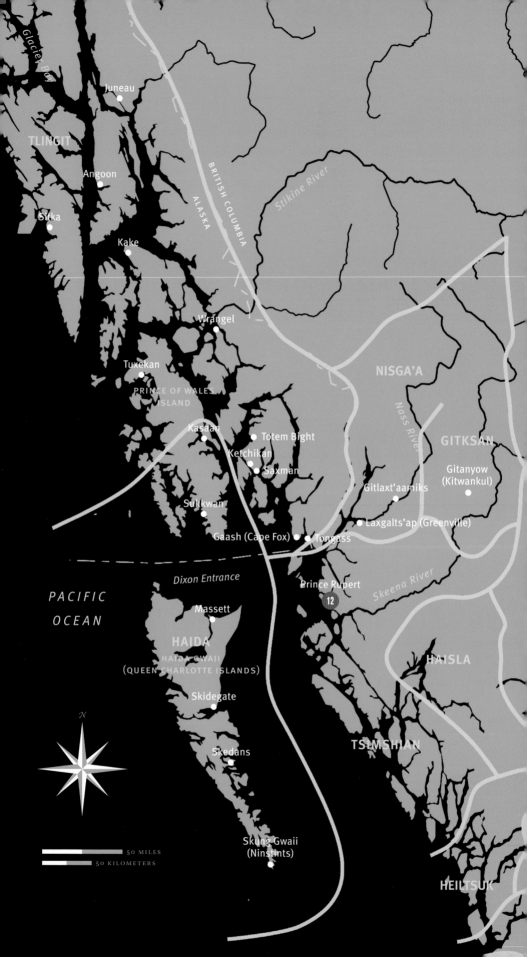

PRINCE RUPERT

12 EAGLE ON THE DECAYED POLE AT PRINCE RUPERT
BY DEMPSEY BOB AND GLEN WOOD: THE RAILROAD,
COPIES OF A POLE, TREATIES, AND REPATRIATION

Ferry and cruise ship passengers
docking in the pleasant city of
Prince Rupert, the northernmost
major community before you reach
Alaska, can wander about and see
a good number of totem poles. This
is Tsimshian territory, so it is ironic
that most of the poles are Haida (fig.
44). The poles were originally placed
there to appeal to tourists, many
of whom arrived in Prince Rupert
by train, having sped through the
beautiful and breathtaking scenery
of the route along the Skeena River.
Early in the twentieth century, the
Canadian National Railway (CNR)
company, recognizing the attrac-
tiveness of totem poles for visitors,
acquired several poles from Haida
Gwaii and erected one at Jasper, the
beginning of the line going from the
Rocky Mountains to the Pacific, and
several more in Prince Rupert, the
terminus of that route. Around 1930,

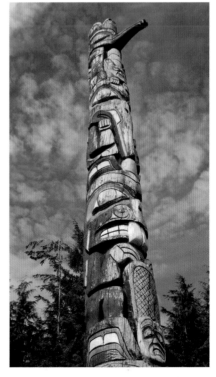

44 Haida, Copy of Eagle and Beaver pole,
Sgaang Gwaii pole, Prince Rupert. Photo by
Aldona Jonaitis, 2010.

43

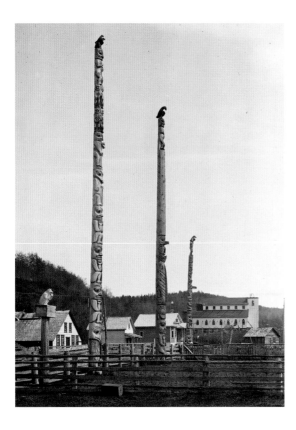

45 Nisga'a, Gitlaxdamiks, Eagle on the Decayed Pole (*left*), 1928. Royal British Columbia Museum, PN 669.

46A-B Dempsey Bob (Tahltan) and Glen Wood (Gitk'san), Eagle on the Decayed Pole, 1978. Photos by Aldona Jonaitis, 2010.

the CNR purchased a Nisga'a carving named Eagle on the Decayed Pole that had once stood in the village of Gitlaxdamiks on the Nass River (fig. 45). They erected it in Prince Rupert, about a hundred miles from where it had originally stood.

The CNR purchased this pole from Marius Barbeau, a French-Canadian anthropologist who worked tirelessly to define a "Canadian culture" distinct from that of the United States. Part of his project was to promote the uniquely Canadian Native art. Barbeau was especially smitten by Nisga'a carvings, deciding that they epitomized the finest Canadian First Nations art. He collected numerous poles in Nass River communities, and he sold this one to the railroad. It stood in Prince Rupert until 1963, when William Jeffrey made a copy and the original was sent to the Royal British Columbia Museum in Victoria. A ferocious windstorm destroyed Jeffrey's copy, and in 1978 Dempsey Bob and Glen Wood made the version that now stands near the Museum of Northern British Columbia in Prince Rupert (fig. 46).

The original Gitlaxdamiks pole is no longer at the Royal British Columbia Museum, having been repatriated to the Nisga'a as a result of an historic treaty between that First Nations group and the British Columbia provincial and Canadian national governments. Except for a small number of communities, no coastal British Columbia Native people had ever signed a treaty with either provincial or federal governments. Fully a hundred years

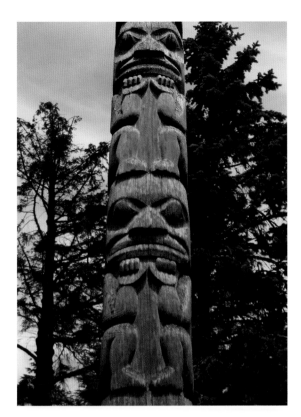
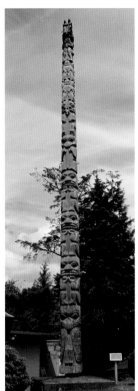

ago, the Nisga'a formed their Land Committee and began petitioning for a treaty. Very little happened until 1927, when a Canadian law made it illegal for anyone to raise money to support a Native land claim—which effectively prevented anyone from going to court. That law was repealed in 1951, when the Nisga'a resumed their efforts to gain official title to their lands. Treaty negotiations with the federal government began in 1976, and the BC government joined the talks in 1990. A final treaty—and the first modern-day treaty in British Columbia—was made official on April 13, 2000.

While most of the treaty involves land and resources, and is predicated on the Nisga'a right to self-government, there is a section that concerns cultural traditions. During negotiations, it was agreed that some two hundred artifacts then held at the Canadian Museum of Civilization and the Royal British Columbia Museum would return to the Nisga'a, who would house them in a state-of-the-art museum, Hli Goolth Wilp Adokshi Nisga'a in Greenville, BC. Of these treasures, The Eagle on the Decayed Pole is one of the most important to the Nisga'a, who selected it as an object for repatriation. Thus the original pole, which dates to the 1870s and is now in the Nisga'a community of Laxgalts'ap (Greenville), will be near the second copy in Prince Rupert, allowing the intrepid traveler to see both and to appreciate the political saga of this First Nation rather than the clan story the original pole represented.

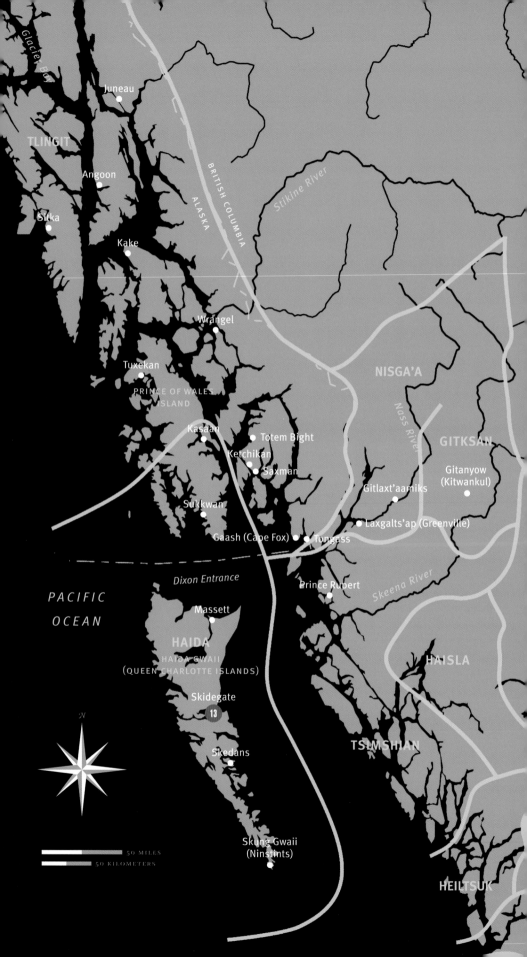

HAIDA GWAII

13 QAY'LLNAGAAY (SEA LION TOWN):
SKIDEGATE THEN AND NOW

If there is one photograph of nineteenth-century totem poles that eclipses all others, it is the image of Skidegate, Haida Gwaii, taken in 1878 by George Mercer Dawson (fig. 47). A long row of pitched-roof dwellings built of cedar planks faces a curving beach. At least twenty poles rise above the houses, their people and animals gazing toward the water. Large dugout canoes on the cobbles are ready to transport residents from the village. It is a magnificent and majestic scene. There is no way for a viewer to know this image is deceptive in its apparent peacefulness and beauty.

Sixteen years before this photograph was taken, a smallpox epidemic devastated the Haida. Before the eighteenth century, 14,200 Haida lived in numerous villages throughout the coast of this archipelago. But by the mid-nineteenth century, only 1,598 remained. These survivors had to abandon their traditional communities, depleted of residents, and move to one of only two villages that remained viable—Skidegate or Masset. Photographer Dawson, on Haida Gwaii for the Canadian Geological Survey, described those abandoned villages as deserted, decaying, and overgrown with weeds. Skidegate, in contrast, had residents, but only the few living remnants of what had once been a substantial and formidable population.

Very few totem poles were raised on Haida Gwaii after 1880, as the Haida embraced Christianity, abandoned the potlatch, and welcomed schools. Yet despite their willingness to accept modernity, the Haida were still poorly treated by outsiders, who appropriated their lands and discriminated against them. By the 1960s, the Haida, like Native peoples worldwide, were contesting their treatment by the dominant society and fighting for sovereignty over their lands.

47

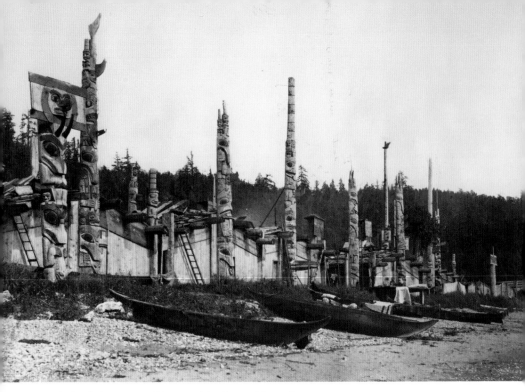

41 Haida, Skidegate, 1878. Photograph by George Mercer Dawson.
Canadian Museum of Civilization 253.

One element in this new political undertaking was to demonstrate the
cultural survival of the Haida in the form of totem poles, which became
the symbol of their enduring strength. The first totem pole to be raised on
Haida Gwaii in ninety years happened in 1969, when Robert Davidson, who
would soon become an internationally recognized artist, erected a pole in his
community of Masset. After that, numerous poles have been erected in both
Masset and Skidegate.

Skidegate, with a current population of 850 Haida, wanted to celebrate its
unique cultural heritage—and to encourage cultural tourism—and in 1998
embarked on an ambitious project to create a new "village" of Haida-style
houses lined up along a beach. It was created to resemble nineteenth-century
villages, and would include a museum, cultural center, restaurant, gift shop,
art school, and carving shed. They named it Qay'llnagaay, or Sea Lion Town
(fig. 48). Each house has a totem pole before it that represents each of six
traditional Haida communities. Five poles are attached to the house facades,
and one stands separate, looking out to sea (fig. 49).

In addition to signifying Haida cultural strength and affording a source
of income to the community through the tourist industry, this village alludes
powerfully to Skidegate, its nineteenth-century predecessor, as portrayed by
Dawson. Qay'llnagaay declares that the Haida are still a major force, and will
ultimately win their battles with the government to have full control over
their lands.

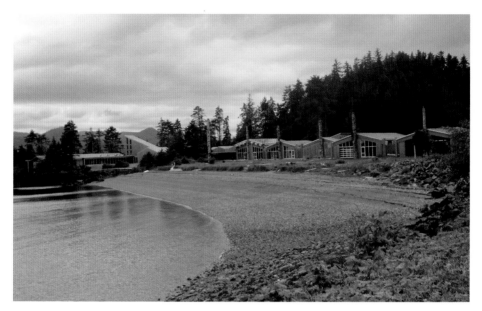

48 Haida, Qay'llnagaay, or Sea Lion Town. Photo by Aldona Jonaitis, 2010.

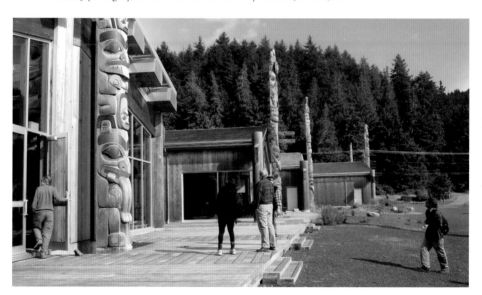

49 House fronts, Qay'llnagaay, or Sea Lion Town. Photo by Aldona Jonaitis, 2010.

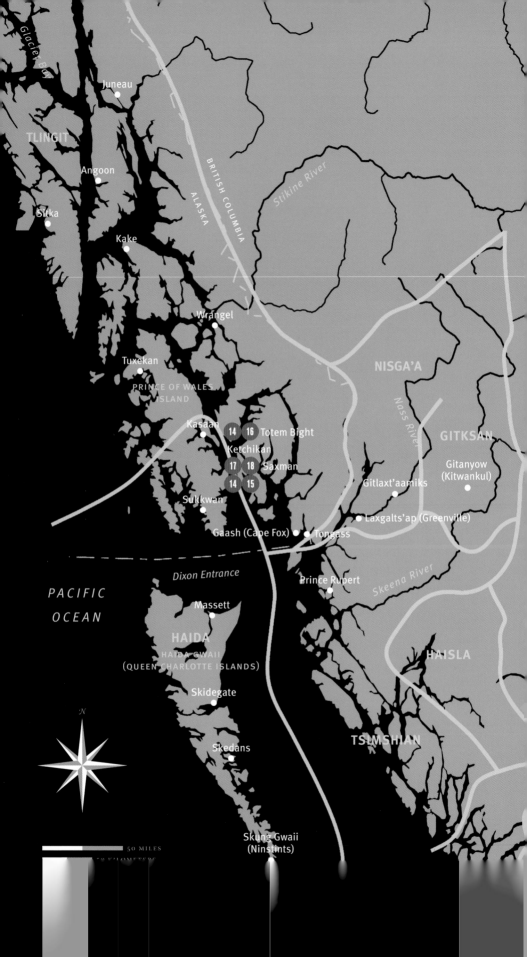

KETCHIKAN

SAXMAN AND TOTEM BIGHT:
KETCHIKAN TOTEM PARKS AND ALASKAN RACISM

A fact little known outside Alaska is that the territory enforced segregation between Natives and whites. Signs such as "No Indians or Dogs allowed" appeared before numerous stores and restaurants and were expressions of discriminatory laws and practices that date to the end of the nineteenth century. Being Native was considered bad and indeed shameful, and many young people grew up to disdain, or at least reject, their heritage. During the 1930s Depression, a government-sponsored project had the unintended (although certainly welcome) consequences of restoring pride among its Native participants.

As was the case elsewhere throughout the Northwest Coast, after whites began to settle Alaska, many Native families left their traditional villages and moved to the newly formed towns for available jobs; for example, residents of Tongass and Gaash had moved to Ketchikan by 1899, so those villages appeared abandoned, although families retained possession of their original houses and related carvings (see pp. 3–5 and 6–8). By the late 1930s, most of the totem poles that still stood had suffered from the elements and would soon become one with the earth if nothing was done. And something was done. This was the Depression and the Indian Civilian Conservation Corps had been formed to provide work for the increasingly desperate Native American population, in Alaska as well as in the Lower 48 states. The deteriorating totem poles and the Southeast Alaska Natives' need for employment turned out to be a perfect opportunity for an Indian CCC project.

In 1938, the Corps worked with the U.S. Forest Service to organize Tlingit and Haida men into teams to remove poles from villages, move them to com-

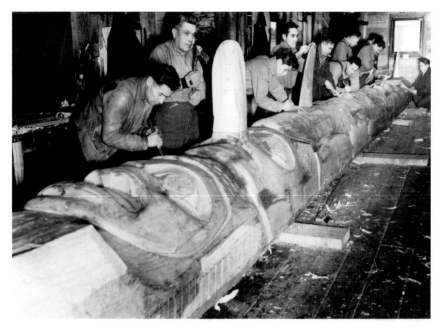

50 Tlingit men carving a totem pole, Saxman, 1939. Photo by Otto C. Schallerer. University of Washington Libraries, negative no. NA3854.

munities with larger populations, and either restore or replicate them (fig. 50). Some new poles were created as well. The resulting poles, numbering over one hundred, were erected in several southeast Alaskan towns. Many ended up in Ketchikan, either at Saxman Village or Totem Bight, where they became the most popular cultural attractions in all of Alaska, welcoming thousands of people arriving in cruise ships for the day, who could take a tour to one or both of these totem pole parks (figs. 51, 52).

During the restoration project, older men with carving or woodworking experience became the "bosses" of teams of younger men who had little or no such training. For many of the young workers this turned out to be a pivotal experience, for Native men were being paid for preserving part of their heritage, now deemed worthy of financial support. By working with their elders, these young Tlingit and Haida learned about their cultures in a way that celebrated rather than belittled them.

The reintegration into their own traditions was in a way the most important outcome of this project. As coordinator Linn Forrest explained in a report, "I think it did an awful lot for the younger fellows that were part of the program. . . . It gave them back an interest in their history that they probably would have lost. . . . These fellows were proud of their work; it meant something to them—I think much more to them after we started the project than it ever did before." This increasing self-esteem paralleled a growing

51 Saxman Village, Ketchikan. Photo by Patty Kastelic, 2011.

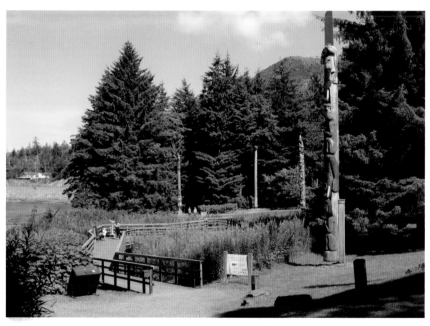

52 Totem Bight, Ketchikan. Photo by Aldona Jonaitis, 2011.

realization on the part of Alaskans that their treatment of the territory's first residents was wrong, and in 1945 segregation was made illegal in Alaska, years before the 1964 federal Civil Rights Legislation.

15 A PORTRAIT IN SAXMAN PARK:
WHY IS ABRAHAM LINCOLN ON A TOTEM POLE?

One does not expect to see an image of Abraham Lincoln on a totem pole in Alaska, but there he is, atop one in Saxman Village (fig. 53). This is a copy of a nineteenth-century original that once stood in the village of Tongass. In 1940, Tlingit carvers James Starrish and Charles Brown copied that original as part of the Indian Civilian Conservation Corps project designed to provide jobs during the Depression (figs. 54, 55). The meaning of Lincoln's appearance on this pole has been contested over the years.

Historically, in 1869 Chief Ebbets moved his village from its original location on Cat Island to a new site they called Tongass, which was near a new fort and the U.S. Customs House. According to one of Ebbets's descendants, the chief wanted to raise a pole in 1883 to validate his claim to having been the first member of his community to see a white person. The carver needed a model for the white person, so he asked local soldiers for an image of one; they supplied a picture of Abraham Lincoln. That was how the sixteenth president came to appear at the top of what became known as the Lincoln pole—he was the generic white person.

Fast-forward to the Lincoln Day Dinner in Washington, DC, around 1920. James Wickersham, district judge for Alaska from 1900 to 1908 and a major

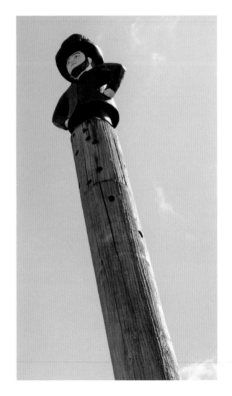

53 (*left*) Tlingit, Lincoln pole, Saxman Village. Photo by Patty Kastelic, 2011.

54 (*middle*) James Starrish and Charles Brown (Tlingit) next to the figure of Lincoln to be placed atop the pole in Saxman Village, 1940. University of Washington Libraries, negative no. NA3806.

55 (*right*) Lincoln pole being raised, Saxman Village, 1940. Photo by C. M. Archibold. University of Washington Libraries, negative no. NA3807.

political figure in the state for decades, gave a speech at that dinner that included reference to the Lincoln pole. According to Wickersham, the Tongass people, with Chief Ebbets, moved close to the U.S. fort for protection against the Kagwantan, an enemy clan, who had enslaved some of Ebbets's clan members. During this process, they encountered the revenue cutter *Lincoln* and learned about that president's legacy as emancipator of the slaves. That same vessel was instrumental in bringing peace to these clans. Lincoln's appearance on Ebbets's pole signified gratitude for his having emancipated not only African American slaves, but Tlingit slaves as well. Wickersham repeated this story in 1924, when he published "The Oldest and Rarest Lincoln Statue" in *Sunset* magazine.

This outraged William Lewis Paul, a Tlingit lawyer, legislator, political activist, and a descendent of Chief Ebbets, who informed Wickersham that his story was totally untrue; Ebbets's clan had moved to Tongass because the American presence offered better opportunities for trade. Moreover, no member of this clan had ever been enslaved (although slavery had been practiced among the Tlingit and other Northwest Coast groups). In truth, it was a federal judge, Lafayette Dawson, who—several decades after the Civil War—had outlawed slavery in Alaska. Clearly the very notion that a Tlingit group would have commemorated Lincoln as their own emancipa-

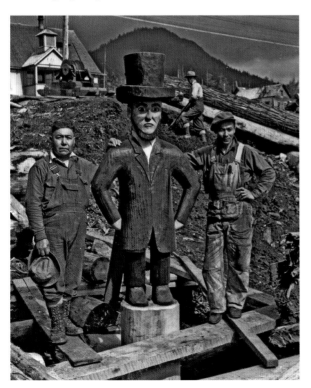

tor was not even historically accurate. Paul provided Wickersham with the story cited at the beginning of this section, but the judge preferred his own inventive version.

Unfortunately, Lincoln as emancipator of Tlingit slaves has more appeal to the public than Lincoln as a generic white man, and Wickersham's story has had considerable staying power. Even guides at Saxman Village will sometimes tell versions of this story. Only at the Alaska State Museum, on the label interpreting the original carving of Lincoln from the Tongass pole, is Paul's story cited.

But there's more. According to Rosita Whorl, president of the Sealaska Heritage Institute, neither of those stories is accurate. She asserts that Lincoln as the emancipator is meant to appear on the pole, but in shame, not in honor, because when the U.S. government forced the Tlingit to give up their slaves the owners were never properly compensated for the loss of these valuable commodities.

It is unfortunate that there is no written record of Chief Ebbets' account of why Lincoln appeared on this pole. Without his words, the story of this pole—like so many other clan-owned narratives—cannot be widely known or shared.

(16) THE CLAN HOUSE AT TOTEM BIGHT:
A HOUSE, A POLE, AND PEOPLE BEING
PHOTOGRAPHED

In addition to restoring and replacing totem poles in the late 1930s, the Indian Civilian Conservation Corps (see pp. 51–53) oversaw the construction of three clan houses, one in Wrangell (fig. 56), one in Kasaan, and one outside Ketchikan in Totem Bight (fig. 57). Linn Forrest, manager for the program, envisioned at Totem Bight a Native village with several houses and totem poles lined up along the beach (much like the Sea Lion Town in Skidegate today, pp. 47–49). That passengers on ships and ferries passed by this site enhanced its touristic potential.

Forrest, Tlingit Charles Brown (see pp. 54–55), and John Wallace, an experienced Haida totem-pole carver, designed the plan, which was to have both Tlingit and Haida structures. Unfortunately, World War II put an end to this ambitious public project. Today, Totem Bight contains just one house with an attached totem pole and several freestanding poles lining a curving path along the beach.

But it is a most interesting house, as no real prototype for it exists. Charles Brown designed the painted facade, interior house posts, and the

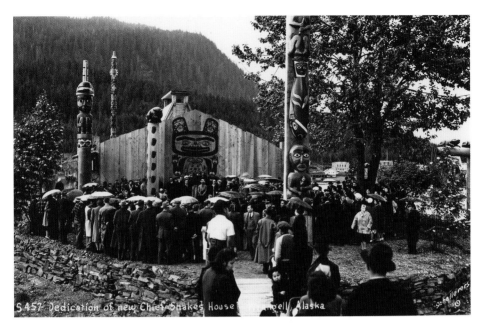

5457 Dedication of new Chief Shakes House, Wrangell, Alaska

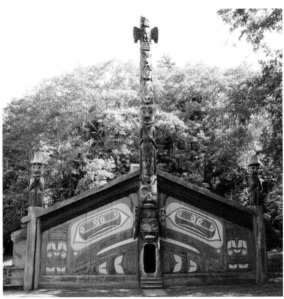

56 Tlingit, dedication of Chief Shakes house, Wrangell, 1940. Photograph by W. H. Case. Wrangell Museum Collection, 199002096.

57 Tlingit and Haida, Clan house, Totem Bight. Photo by Aldona Jonaitis, 2011.

exterior pole attached to the facade that served as entrance and exit to the structure. Although some Tlingit painted their house facades, such as this building from Cape Fox photographed in 1899 (fig. 58), it was the Haida who made frontal house poles, such as the Skedans pole on exhibit at the University of British Columbia Museum of Anthropology (fig. 59). So what you see at Totem Bight is a creative amalgamation of two artistic traditions in one structure, a result by no means surprising since a Haida and a Tlingit jointly conceived the original village. This should not be considered a criticism of the nontraditional nature of this building, for Charles Brown, John Wallace,

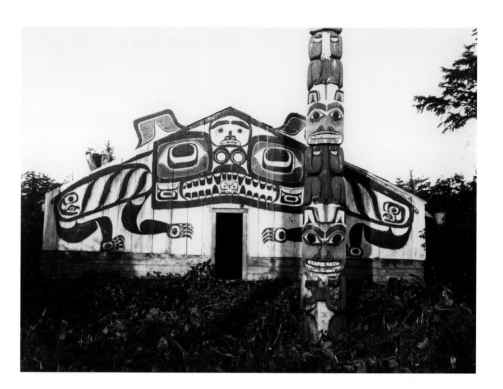

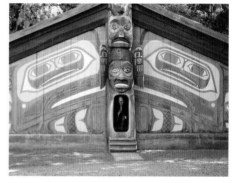

58 (*top*) Tlingit, Cape Fox facade and totem pole, 1899. Photo by Edward S. Curtis. University of Washington Libraries, negative no. NA2132.

59 (*left*) Haida, Skedans, house frontal totem pole, ca. 1870. Collected by Wilson Duff and others in August 1954. University of British Columbia, Museum of Anthropology, A50001.

60 (*right*) Tlingit and Haida, Clan house with woman exiting through facade opening, Totem Bight. Photo by Aldona Jonaitis, 2011.

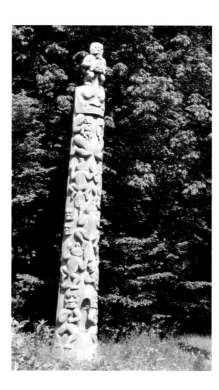

61 Norman Tait (Nisga'a), Beaver Crest pole, 1987. Stanley Park, Vancouver. Photo by Aaron Glass, 2010.

and Linn Forrest created a *new* type of house for a new situation, that is, for an attraction specifically designed for the tourist.

The Totem Bight house is probably the most photographed of all the CCC houses, and not simply because more tourists come to Ketchikan than to Wrangell or Kasaan. Hundreds of visitors to the park have their photograph taken as they exit the house through a large oval hole at the base of the attached pole (fig. 60). Being photographed next to—or, in this case, inside of—a totem pole has appealed to tourists since they first started taking cameras on their trips up the Inside Passage (see fig. 64, p. 61). In Stanley Park, where many visitors pose before poles, Nisga'a artist Norman Tait raised a pole with a hole at the bottom (fig. 61); his original idea was to have the two lowermost figures extend their elbows in such a way that a person could link arms with them and thus become truly part of the pole for a picture. Unfortunately, doing so would have made the arms too fragile, and Tait abandoned that idea. Yet today a visitor can be photographed crouching between these figures with hands on their elbows. One wonders if Charles Brown was as conscious of the photographic potential of his building as Tait was of his pole!

Ketchikan is now a bustling tourist destination as well as the fourth largest city in Alaska. But until the 1880s, the only buildings there were temporary shelters used during the summer fish camps for Tlingit from nearby Tongass and Cape Fox. They fished at Ketchikan Creek which, as it still does today, became red with salmon swimming upstream to spawn. In 1885, an entrepreneur by the name of Mike Miller convinced Chief Kyan, whose clan owned land there, to sell him 160 acres so that he and his associate George Clare could build a fish saltery and trading post. Although their business failed, it was on this land that the city of Ketchikan was built.

In the late 1800s, Chief Kyan had a pole carved and erected on land that today is the parking lot for the Centennial Building, at 629 Dock Street. That carving fell down in the teens or early 1920s and ultimately deteriorated. A copy by Stan Marsden replaced it in 1966. When it too deteriorated, Israel Shotridge carved the third version in 1993, which today stands in Whale Park (fig. 62).

Totem poles have fascinated tourists from the time the first intrepid travelers made their way up the Inside Passage on steamers from San Francisco and Seattle. That trip was dubbed "The Totem Pole Route" by the Pacific Coast Steamship Co., which graced the cover of its 1906 brochure with a totem pole image (fig. 63). Just as they did then, visitors enjoy having their photographs taken in front of poles, such as these three ladies and one gentleman who posed beside Chief Kyan's pole at the turn of the century (fig. 64).

Before their journeys to the north, some people imagined that the Native people they would encounter would be simple Indians, people who lived closer to nature,

62 Isreal Shotridge (Tlingit), copy of Chief Kyan pole, 1993, Ketchikan. Photo by Patty Kastelic, 2011.

 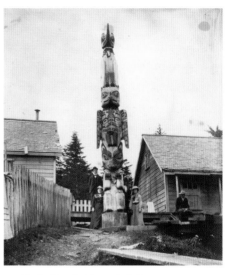

63 (*left*) Pacific Coast Steamship Company brochure, *Alaska Via the Totem Pole Route*, 1906. Alaska State Library, M68-1-01-05.

64 (*right*) Tourists posing with the Chief Kyan pole, Ketchikan, ca. 1900. Alaska State Library, P44 03 079.

perhaps as the human equivalent of the wilderness they would experience in Glacier Bay and other fjords and inlets. Much to their disappointment, most of the Native people tourists saw were like the man sitting next door to the Kyan pole, apparently unconcerned about the photographic goings-on. These Native people wore manufactured clothing, lived in Western-style houses, and exhibited little of what would qualify as "exotic." Many tourists to Alaska wanted to see "authentic" Indians, which they romanticized as representing the "noble savage," and so lamented the modernization of Native people they saw. They did not have the cultural awareness to comprehend their own participation, as residents of the colonizing country, in the destruction of the Native culture through the Indian policy of the United States government at the time.

It was in this way quite easy to separate Alaska Native people, many impoverished and despised by racists, from their glorious artistic traditions—especially in the form of totem poles. These elegant carvings with their mythic meanings and impressive size became monuments dissociated from the living Indians whom the tourists preferred not to encounter anyway. Thank goodness that is no longer the case, as numerous visitors now seek out Native people, including those they encounter at Saxman, Alert Bay, and elsewhere on the coast.

 THE KETCHIKAN INDIAN COMMUNITY TRIBAL HEALTH
CENTER TOTEM POLES: NATIVE IDENTITY

On the way to the Ketchikan International Airport one passes three totem poles standing in front of the four-story Ketchikan Indian Community Tribal Health Clinic. Erected in 2005, these poles represent the Native groups who live in the region served by this clinic: the Tsimshian on the left, carved by David Boxley; the Tlingit in the center, carved by Israel Shotridge; and the Haida on the right, carved by Donald Varnell (fig. 65). The Boxley (fig. 66) and Shotridge poles (fig. 67) adhere to the conventions of their traditions. But the Varnell pole (fig. 68a, b) departs from the restrained elegance of the Haida canon. It has many strange faces: the uppermost looks cartoonlike, the second is a bird with an unconventional eye that from a distance looks mottled, while the third is a strikingly naturalistic face with large human eyes gazing upward as if in a trance. The lowest face is an upside-down being with pupils straining downward and a tongue extending upward. This pole is clearly based on northern Northwest Coast artistic traditions, but Varnell has taken them to an entirely new level. Varnell is close friends with Stephen Jackson, whose Bear Mother pole at the Burke Museum (fig. 6, p. 7) is equally unusual and innovative.

Like others along the coast that we have already discussed, these poles have a significant message for the public: the land on which they stand, and the building they introduce, are *Native*. The history of Ketchikan, the entire Northwest Coast, and, indeed, aboriginal communities worldwide chronicles the imposition of alien values as well as the appropriation of lands and culture; just consider the number of totem poles that have been used to designate British Columbia and Alaska. These three poles indicate that the Native residents of the region have regained control of their lives and their culture. They clearly mark this *particular place* as indigenous space, similar to the way in which poles in front of houses marked the presence of specific clans.

Reading these poles provides interesting insights into the nature of the present-day Native community. Shotridge's pole is tallest and central, as is appropriate to the Tlingit who significantly outnumber the Tsimshian and Haida and upon whose traditional lands Ketchikan sits. Boxley's and Shotridge's poles convey the importance of tradition and tribal identity as expressed by these poles that draw heavily upon the past. Varnell's carving, in contrast, conveys the importance of living in the present, honoring the past while embracing the future. Together, all three communicate the complex nature of cultural identity and contemporary indigeneity in Southeast Alaska.

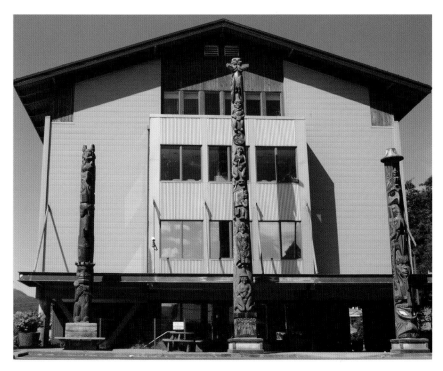

65 (*top*) Ketchikan Indian Community Tribal Health Clinic totem poles. Photo by Aldona Jonaitis, 2011.

66 (*center left*) David Boxley (Tsimshian), totem pole, 2005. Photo by Aldona Jonaitis, 2011.

67 (*center right*) Israel Shotridge (Tlingit), totem pole, 2005. Photo by Aldona Jonaitis, 2011.

68A, B (*bottom left and right*) Donald Varnell (Haida), totem pole, 2005. Photos by Aldona Jonaitis, 2011.

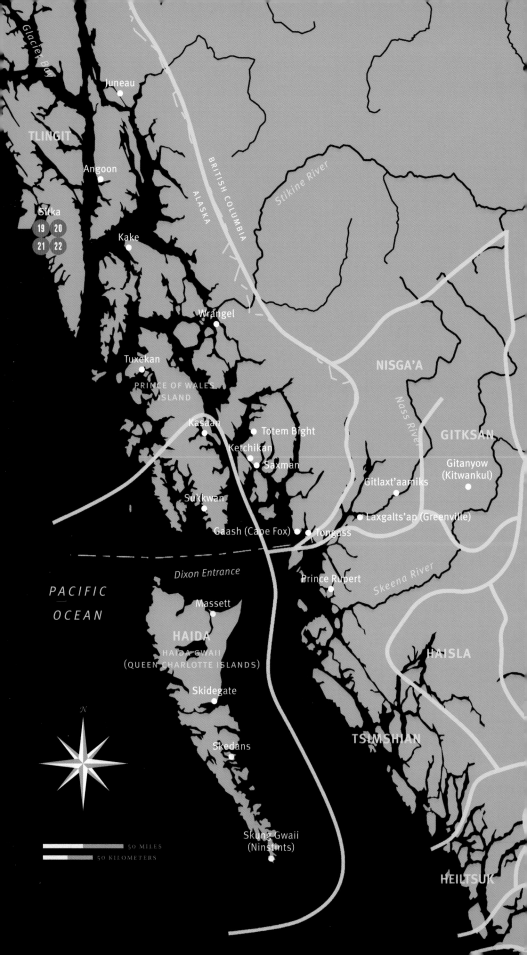

SITKA

19 CHIEF SAANAHEIT'S POLES AT THE SITKA NATIONAL
HISTORICAL PARK: TOTEM POLES WHERE ONCE THERE
WERE NONE

In 1885, Eliza Scidmore, author of a popular travel guide to Alaska, com-
mented on how Sitka had little to entice the tourist: "There are no totem
poles, or . . . [traditional plank] houses to lend outward interest to the vil-
lage" (175). Indeed, nineteenth-century drawings and photographs depict
the Tlingit village's houses lined up along a curving beach with no carved
monuments. Historically, no exterior poles were raised in the northern part
of Tlingit territory, perhaps because cedars, the best trees for these monu-
ments, do not grow that far north. Instead, there were interior house-posts
that depicted clan crests. Today, one of the most popular attractions of this
beautiful community is the totem pole–filled National Historical Park. How
could a town that had no poles come to have so many?

John Brady, who served as governor of the District of Alaska from 1897
to 1906, had come to Alaska as a missionary in 1878. After a few years, he
opened several businesses in Sitka, for he could not live on his church activi-
ties alone. During his years in Southeast Alaska, Brady met and came to
admire the Native people he encountered, and became deeply concerned that
so many of them were abandoning their cultural traditions. Brady shared the
paradox felt by so many Native sympathizers of that time: that while progress
toward civilization was good, the resulting cultural loss was bad.

One of Brady's passions was to preserve totem poles and other Native
artworks so that future generations of fully civilized and westernized Tlingit
and Haida would know their history. So, in 1900, he traveled to various vil-
lages south of Sitka where totem poles still stood and asked their owners
to donate them to a new totem park he was planning in what would be the

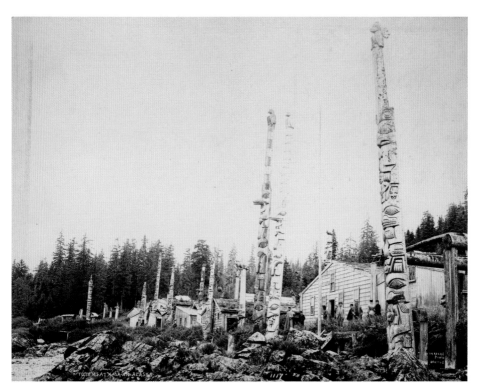

69 Kasaan, ca. 1900. Photo by Frank LaRoche. Alaska State Library, P130–010.

National Historical Park. Everyone turned him down. Refusing to become discouraged, Brady persisted and in 1901 convinced a high-ranking Haida, Chief Saanaheit of Kasaan, to donate some of his treasures.

In 1901, Kasaan still had large communal houses and numerous totem poles, and was a popular stop on the Inside Passage "Totem Pole Route" (fig. 69). Convincing this chief to relinquish not only a tall, beautifully carved totem pole but also four house posts and a canoe was a pivotal moment in Brady's project, for after this many other chiefs agreed to entrust their poles to him.

Figure 70 is a photograph of Saanaheit's pole being taken down; Brady stands next to the pole and Saanaheit is third to the left (fig. 70). Soon the carvings were placed on a steamer and shipped to Sitka. As was so often the case, over the decades the pole deteriorated, and in 1941–42, George Benson and Peter Jones, working for the Indian CCC, carved a copy of the pole. And in 1981–82 Reggie Peterson copied the house posts. These are the monuments a visitor to the Sitka National Historical Park can see today (fig. 71).

One might wonder why the chiefs were willing to give Brady their poles for nothing, when rapacious collectors hired by museums would pay considerable sums for these monuments. Certainly Brady did enjoy excellent relationships with many Tlingit and Haida. Furthermore, from a Native point of view, this arrangement with Brady made good sense; giving these poles

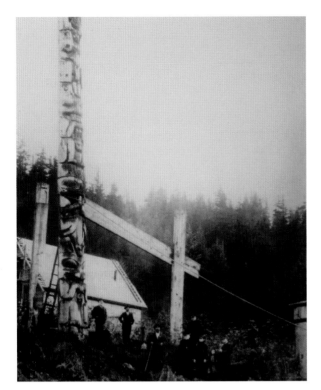

10 (*left*) Kaigani Haida, Kasaan, taking down the Saanaheit pole, 1901. John G. Brady Papers, Beinecke Rare Book and Manuscript Library, Yale University, New Haven, Connecticut.

11 (*right*) Saanaheit pole and house posts, Sitka National Historical Park. Pole by George Benson and Peter Jones, 1941–42; house posts by Reggie Peterson, 1981–82. Photo by Aldona Jonaitis, 2010.

away enhanced their prestige, just as giving away large sums of money at potlatches did. Audiences at even the largest potlatches might number in the hundreds, whereas in Sitka, thousands of people would witness this display of rank. And the agreement also guaranteed that the poles stayed within their own territory rather than being sold to museums and shipped across the continent. In this way, while perhaps losing the opportunity for material gain, Saanaheit and the other donors instead gained prestige, which was always more important.

20 SITKA'S MONUMENTS AT WORLD'S FAIRS: TRAVELING POLES

As governor, John Brady had an ambitious plan for the territory of Alaska: statehood. But to gain that status it needed a larger non-Native population. The opportunity to educate the public that Alaska was not a frozen wasteland arose when St. Louis announced it would host the 1904 Louisiana Purchase Exposition. Brady's Alaska building there would educate thousands of people about the excellent opportunities for life in Alaska.

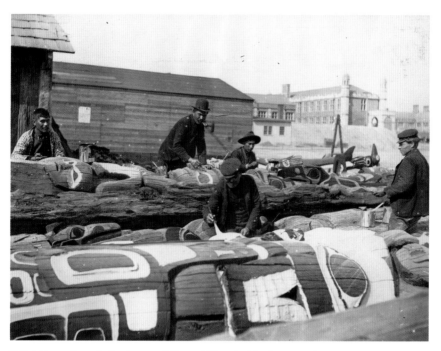

72 Painting poles at St. Louis, 1904. Missouri Historical Society, negative no. 20887.

But how to attract those fair-goers to the Alaska building? Brady's answer was simple: totem poles! He wrote that totem poles "had great power of attraction," as demonstrated by the thousands of tourists who sought them out when traveling on the Inside Passage. A stand of poles outside the Alaska building would surely bring large numbers of people into the building. And Brady already had a number of fine poles.

Although the ultimate plan for the poles he requested from Haida and Tlingit families was to erect them in the National Historical Park (see pp. 69–70), Brady thought these would make excellent advertisements for his territory. And he sent fifteen poles, two carved planks, four interior house posts, a canoe, and two complete houses to St. Louis. He also sent a crew of Native workmen to ensure the carvings were properly raised. Unfortunately, union rules prohibited such "interference," and all the Alaskans could do was freshen up the paint (fig. 72). Imagine these men's surprise and horror when they discovered the white workmen had put one of the poles in upside down! Yet in the end the poles and house were erected and properly graced the front and side of the Alaska building, the first of its kind at an international exposition (fig. 73).

The St. Louis fair ended on December, 1, 1904, but Brady's poles did not return immediately to Sitka, for another fair was to be held in Portland,

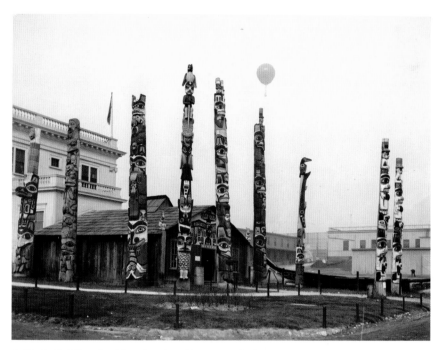

73 Alaska Building, Louisiana Purchase Exposition, St. Louis, 1904.
Missouri Historical Society, negative no. 15775.

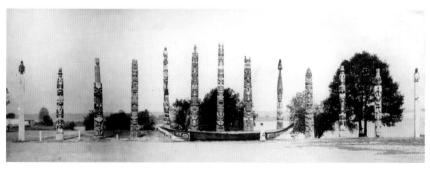

74 Lewis and Clark Exposition, Portland, Oregon, 1905. Sitka National Historical Park, no. 3830.

Oregon, the next year to celebrate the anniversary of the Lewis and Clark expedition. There, twelve poles stood in a line, with the canoe before them in the center (fig. 74).

In January 1906, these poles finally returned to Sitka, to be erected along a popular trail that wound through thick spruce forest near the beach. Today, a visitor to Sitka can stroll along that same path, lined not with the original Brady poles, but with copies and, in several cases, generations of copies. For example, one of the poles, the Gaanaxadi Raven Crest pole originally stood in the Tlingit village of Tuxekan; in the photograph, the donor, Chief Gunyha, stands next to the pole (fig. 75). That pole appears fourth from the left in fig-

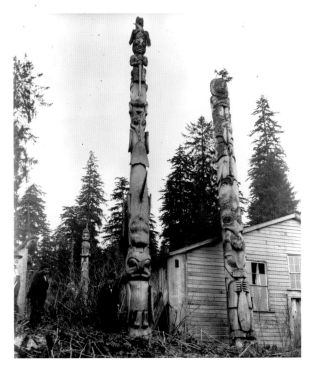

75 (*top left*) Tlingit, Gaanaxadi Raven Crest pole in the village of Tuxekan, ca. 1900. Sitka National Historical Park, no. 3826.

76 (*top right*) Nathan Jackson (Tlingit) and Steve Brown, copy of the Gaanaxadi Raven Crest pole, 1983. Photo by Aldona Jonaitis, 2010.

77 (*bottom*) Poles at the Alaska "igloo" at New York World's Fair, 1964–65. Sitka National Historical Park, negative no. 14930.

ure 2 at St. Louis, and fifth from the left in figure 3 in Portland. After several decades standing in the rainy Sitka forest, the pole needed to be replaced, which was done in 1939 by George Benson, funded by the Indian CCC project (see pp. 51–53). That pole too deteriorated, and in 1983, Nathan Jackson and Steve Brown carved the pole that now stands along the forest trail (fig. 76).

These poles in Sitka have certainly moved around quite a bit. A few of them even went to the New York world's fair in 1964–65, where they graced the igloo-shaped Alaska pavilion (fig. 77). Throughout these voyages, the totem poles have served as attractive and *attracting* symbols of Alaska.

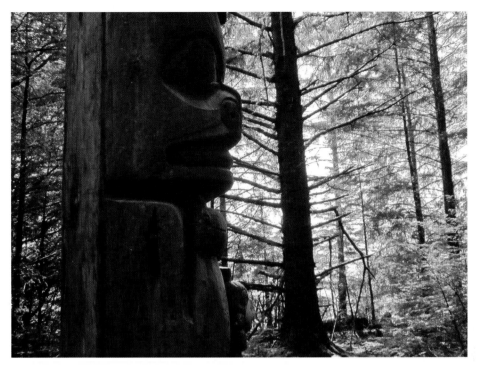

78 Sitka National Historical Park. Photo by Aldona Jonaitis, 2010.

21 THE K'AYLAAN POLE BY TOMMY JOSEPH: CORRECTING HISTORY IN SITKA

Sitka National Historical Park is, in some ways, a microcosm of the whole totem pole story (fig. 78). Poles stand today in many places they did not in the past. Poles attract tourists. When poles finally ceased being carved due to the forces of colonization, some more sympathetic white people wanted to preserve them, as did Governor Brady. Poles became attractions at world's fairs. Government-sponsored projects provided work for Native men who learned about their traditions, as in the Indian CCC restorations of the Sitka poles. As those poles decayed, replacements were made, such as the newer poles at Sitka. Then in 1999 a new pole was raised; it was not a copy of an earlier pole, but a monument to Tlingit pride and sovereignty over their own history.

The first non-Native settlers in Alaska were the Russians, whose main interest in this land was as an abundant source of furs, especially those of the sea otter. In 1799, the Russian-American Company, a commercial venture that served as the government, came to the Tlingit village of Shee Atika— which would eventually be called Sitka—and established a trading fort several miles to the north. At first the Kiks.adi, the Tlingit clan who lived there, were happy to trade with the Russians but soon found their presence undesir-

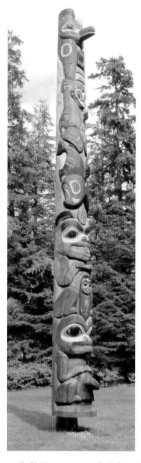

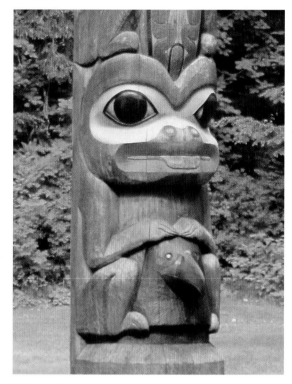

79 (*left*) Tommy Joseph (Tlingit), K'aylaan pole, 1999. Sitka National Historical Park. Photo by Aldona Jonaitis, 2010.

80 (*right*) Detail of K'aylaan helmet, Tommy Joseph (Tlingit), K'aylaan pole, 1999. Sitka National Historical Park. Photo by Aldona Jonaitis, 2010.

able and, in 1802, raided the trading fort and killed almost everyone there—the Russians, as well as their enslaved Aleuts. The Russians naturally would not tolerate such hostile actions and, in 1804, sent several ships including a gunboat to Sitka, and engaged in a bloody battle with the Tlingit. Ultimately the Tlingit abandoned their fort and moved, returning only in 1821 at the Russians' invitation.

The fort that Tlingit warriors fought to protect was located on what is now a grassy field near the mouth of the Indian River in Sitka National Historical Park. When Governor Brady was deciding where to put his collection of totem poles, he chose the park in part because it was and is a beautiful place, and in part to commemorate the 1804 battle. A plaque acknowledges this event.

Naturally this did not appeal to all Kiks.adi, who objected to the Russians' version of history. So, in the late 1990s, the clan arranged for Tlingit Tommy Joseph, with Fred Beltram, to carve a pole that would commemorate Chief K'aylaan, the leader of the Tlingit forces and by all accounts a magnificent man and brave warrior. Joseph's pole (figs. 79, 80) was raised right on the fort's grounds in 1999 to provide a more balanced history of this location. At the bottom of the pole is a black raven's head that represents the helmet worm by the chief at that battle. Not far from the park is the Sheldon Jackson Museum, where the original helmet of Chief K'aylaan can be seen. It remains one of the Kiks.adi's most honored and treasured heirlooms, and its appearance on the K'aylaan pole makes a powerful statement of Native authority over the telling of their history.

22 THE SITKA WELLBREITY TOTEM POLE BY WAYNE PRICE: ADDRESSING SOCIAL PROBLEMS HEAD ON

Before their first encounters with Europeans, North American Natives had no alcoholic drinks, but soon after Euroamericans introduced them to it alcohol became a serious problem, and, along with drugs, remains so. Over the years, various programs have been established to help addicts recover and remain sober. One nonprofit organization located in Colorado, White Bison, offers a variety of resources for recovery and promotes the Wellbreity Movement, which offers help for living sober and well and assistance in each individual's lifelong healing process.

In 2005, the Southeast Alaska Regional Health Consortium (SEARHC), which sponsors an assortment of programs for treating problems such as substance abuse, easting disorders, domestic violence, and suicide, worked with White Bison and Wellbreity to support the carving of a new totem pole that would have a Tlingit name that translates "you are going to get well." The artist, Tlingit Wayne Price, himself a recovering addict, is dedicated to using both knowledge and tradition to assist youth to accept a new way of life free from alcohol and drugs. As he states at his website, "It has come to me that it is time for me to pass on my skills as an artist to the youth of today, as well as my sobriety recovery story. I call on thousands of years of history passed down through the carving of wood to help me. Our rich history, culture, and way of life are not lost as long as our art can be held and admired" (silver-cloudart.com).

While the pole was being carved at SEARHC, several ten-member "healing circles," each focused on one of the social and health problems that troubled the community, got together and discussed how Wellbreity could

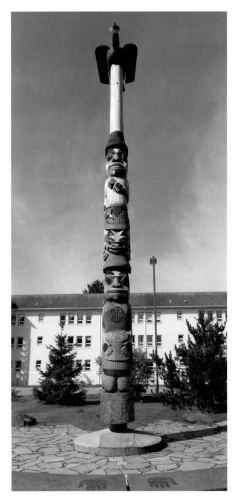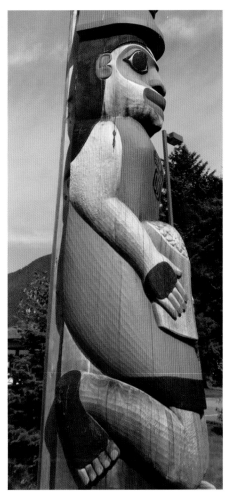

81 (*left*) Wayne Price (Tlingit), Wellbreity pole, Sitka, 2006.
Photo by Nicolas Galanin, 2011.

82 (*right*) Wayne Price (Tlingit), Wellbreity pole, Sitka, 2006, detail.
Photo by Nicholas Galanin, 2011.

assist them on their journey to wellness. As part of this healing process, each circle assisted Price in carving the pole.

The raising of the pole on October 14, 2006, was, in addition to an exciting activity, a community celebration of the presence of Wellbreity in Sitka as well as Alaska as a whole (fig. 81). Hundreds of people helped carry and then pull the pole up, as hundreds more celebrated this new symbol of "Prevention, Treatment, Intervention and Healing," and participated in a great feast. The bringing together of people of different ages and ethnicities was one of the fundamental foundations of the healing process.

The pole itself is replete with references to the problems of alcohol and

drug abuse: a tear falls from the eye of the lowest figure, Medicine Woman, who mourns the loss of those who succumbed to addiction; the spirit wolf above, with its supernatural power, helps people to enter the dark side of addiction and to bring them back from there to recovery; the anthropomorphic bear conveys the brightness of the future; and the raven at the top carries the moon, which signifies hope (fig. 82).

When totem poles stood before clan houses, they certainly did not bear messages of this sort. But today Native communities are making a strong effort to ensure the maintenance of traditions and overcome social ills. The totem pole, as a monument that now enjoys worldwide recognition as a truly great form of Native American art, remains an invaluable means of expressing concepts that the community wishes to be seen, understood, and contemplated.

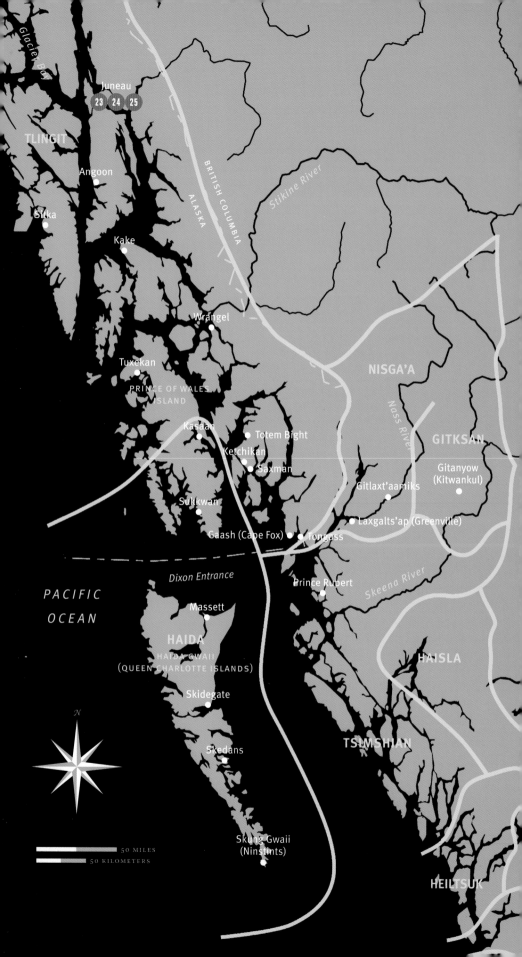

JUNEAU

23 CULTURALLY MODIFIED TREES BY RICHARD BEASLEY
AT MOUNT ROBERTS: FACES IN THE WOODS

On a clear day, the view from Mount Roberts high above Juneau is nothing short of spectacular. There's more than just a view there, though. The path behind the Mountain House leads through a dense rainforest overgrown with moss, and then opens up to bright alpine slopes which, in early summer, dazzle with multicolored wildflowers. Further back in the woods something quite unexpected confronts the stroller: carved onto the side of the tree is a finely modeled bird with a long beak and displayed wings (fig. 83). Then, a bit farther on, a being that looks somewhat human emerges from a large spruce tree (fig. 84). And on returning to the house, a broad face with large eyes and fleshy lips graces the side of a tree rising through one of the outdoor decks (fig. 85).

These unusual carvings, by Tlingit Richard Beasley, use a traditional Northwest Coast technique of collecting bark and wood from living trees, mostly spruce in Alaska and cedar in British Columbia. Cutting into the wood causes sap to flow,

83 Richard Beasley (Tlingit), culturally modified tree depicting a bird, Mount Roberts, Juneau. Photo by Aldona Jonaitis, 2010.

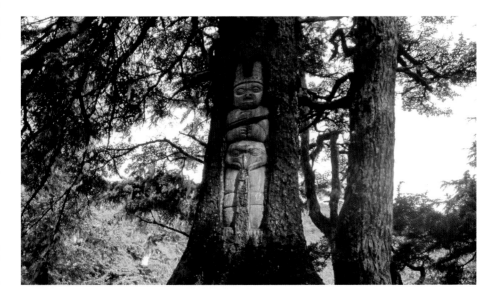

84 Richard Beasley (Tlingit),
culturally modified tree
depicting a human form,
Mount Roberts, Juneau. Photo
by Aldona Jonaitis, 2010.

85 Richard Beasley (Tlingit),
culturally modified tree
depicting a frontal face,
Mount Roberts, Juneau.
Photo by Aldona Jonaitis,
2010.

at least temporarily retarding rot. Bark had numerous uses too, from mak-
ing shingles for temporary dwellings to being shredded for clothing. Near
the National Park Service Headquarters at Glacier Bay are several so-called
culturally modified trees (CMTs) bearing triangular or rectangular scars
showing where someone stripped their bark for household use.

As non-Natives encroached on their territories, Native Alaskans marked
trees for different reasons: one was to prove they owned land. For example,
near the Glacier Bay headquarters some trees contain blaze marks made by a
Tlingit around 1900 to delineate his clan's land for an ultimately unsuccess-
ful claim he filed for government recognition. The people who traditionally
hunted and fished in Glacier Bay, now a national park, still fish and gather
gull eggs there, but by management agreement, no longer hunt seals or ter-
restrial animals.

Beasley's trees on Mount Roberts refer to ownership not by means of
blazes, but through images. When he was in Yukon Territory, he visited the

Champagne and Aishihik First Nation, an Athabaskan group who live on the Canadian side of the Coast Range and have ancient ties with the Tlingit through trade and marriage. Beasley saw trailmarkers in the form of trees bearing relief carvings of beings such as birds and human-formed beings. During the nineteenth century, a powerful Tlingit clan owned the trail that led from the coast to the Interior, which gave them a monopoly on the trade of furs trapped in the Yukon Territory and sold to white traders. These markers were possibly put in place to visually reinforce this monopoly.

The carvings on Beasley's CMTs, which he intended to also serve as trail markers, refer to the Native people of Juneau, and thus identify whose territory it is that they stand upon. In the case of Mount Roberts, that is accurate, since the Native regional corporation owns the attraction and its surrounding land.

24 THE WAASGO POLE AT THE ALASKA STATE OFFICE BUILDING: POWER AND WEALTH IN JUNEAU

Few will dispute that wealth plays an important role in contemporary American culture. Wealth is also an important feature of Northwest Coast culture, and wealth-bringing beings populate many regional myths. In Haida mythology, Waasgo is a supernatural being who lives in water and brings wealth and power to those whom it encounters. It sometimes appears on totem poles, such as the Waasgo Pole, which, interestingly, has conveyed three types of wealth, and thus three sources of power, during the phases of its life history. In around 1880, the chief of the Quit'aas clan of Sukkwan raised this pole in front of his house (fig. 86). In the early years of the twentieth century, Dr. Robert Simpson, who often traveled to remote communities to conduct his optometry practice, purchased the pole from the clan. He and his wife Belle Goldstein Simpson were the proprietors of the Nugget Shop, a curio store that sold high-quality material including totem poles. In 1926, the Waasgo pole stood before the Nugget Shop on South Franklin Street in Juneau (fig. 87). In the 1940s Simpson donated the pole to the city, and eventually it was accessioned by the Alaska State Museum, which in 1977 erected it in the soaring, light-filled lobby of the Alaska State Office Building (also known as the SOB) (fig. 88).

When this pole stood in Sukkwan, it conveyed the status of a high-ranking family in the community whose source of status was wealth given away at potlatches. When it stood before the Nugget Shop, it was connected to a rich settler family, one of the most powerful and important in Juneau at the time.

Belle Simpson was the daughter of Rueben Goldstein, a Russian Jew who

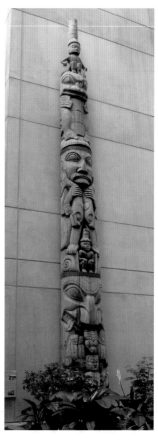

86 (*top*) Kaigani Haida, Sukkwan village,
ca. 1890, with the Waasgo pole at far left.
Alaska State Library, Sukkwan no. 1.

87 (*left*) The Nugget Shop, Juneau,
Alaska, 1926. Photo by Winter and Pond.
Alaska State Library, PCA-87.

88 (*right*) Dwight Wallace (Kaigani Haida), Sukkwan
village, Waasgo Totem pole, ca. 1880. Alaska State
Museum, II-B-1632. State Office Building, Juneau.
Photo by Aldona Jonaitis, 2010.

made his way to England, Canada, and the United States, finally settling in Juneau in 1883, where he opened a general store in 1891. His eldest son, Charles, became a furrier and did so well that in 1914 he built the Goldstein building on Seward Street for his department store, the Goldstein Emporium. Charles's brother Isadore took over his parents' Goldstein's Store, and later went into local politics, serving on the city council and becoming mayor of Juneau in the 1930s. Robert Simpson thus belonged through marriage to a rich and distinguished family, and in the 1940s built the Simpson Building across the street from the Goldstein Building. He also moved the Nugget Shop to this location, and that is when he donated the Waasgo pole to the city of Juneau.

The pole stood outside the Juneau Memorial Library for several decades, where the elements so severely punished it that it was about to fall down and disintegrate. So in 1977 it was brought indoors, restored, and then raised in the eighth-floor lobby of the State Office Building. Here much of the business of the forty-ninth state is conducted and its administrative power is located. Alaska is one of the wealthiest states in the nation, and has the luxury of giving its residents a dividend check each year (as opposed to taxing them). So, here this pole stands, at the building that signifies the power and wealth of Alaska.

25 THE WOOSHKEETAN POLE BY NATHAN JACKSON AND STEVE BROWN: WHITE MEN BEHAVING BADLY

Artists have portrayed Native Americans for centuries, some as early as the drawings of the first Nuu-chah-nulth encountered by Euroamericans on Captain Cook's 1776 voyage, and later in Edward Curtis's romanticized images of the "Vanishing Indian." Native people occasionally depicted white people, and not always in the most favorable light; sometimes they even ridiculed their non-Native subjects, as seen in the pole in Saxman that depicts Secretary of State William Seward, who purchased Alaska (fig. 89). In 1869, Chief Ebbetts of Tongass village hosted an elaborate potlatch for William Seward, who never reciprocated, a grievous social failing. So the Chief raised this pole, which portrays this ignorant man sitting atop a box to display to the world his boorish behavior.

This pole by Nathan Jackson and Steve Brown, carved for the Alaska centennial in 1980, depicts episodes in the Wooshkeetan people's history, including one disgraceful incident with the U.S. Navy. Uncle Sam, with a top hat of stars and stripes and a red, white, and blue outfit, perches at the top of the pole (fig. 90). Named for the clan from Angoon whose history it presents,

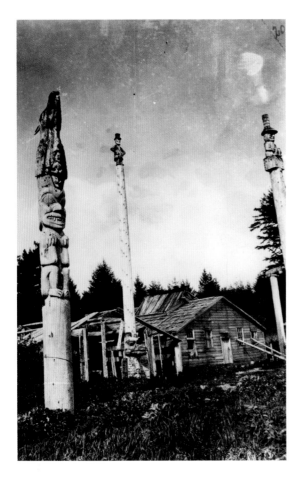

89 Tlingit, Seward pole (*far right*) and Lincoln pole (*center*), Tongass, Alaska, ca. 1920. Photo by S. Riley. University of Washington Libraries, negative no. NA3678.

this pole condemns the actions of the United States military in 1882. After a man from Angoon was accidentally killed while working on a whaling ship, 200 Angoon Tlingit confronted representatives of the whaling company and demanded 200 blankets to pay for this death. It was Tlingit custom to receive payment from those responsible for someone's death. The frightened whaling company workers requested protection from the U.S. Navy. With the arrogance typical of the day, the naval ship's commander ordered the Angoon people to give *him* 400 blankets to pay for their hostile behavior. When the people of Angoon could assemble only 82 blankets, the Navy destroyed forty canoes, shelled and burned the village, and helped themselves to ceremonial regalia and furs.

Members of the tribe have attempted for decades to obtain an official apology from the Navy for this outrageous behavior, so when this totem pole was raised for the Centennial of Juneau, Uncle Sam was positioned on the top as a reminder that the United States Government had never paid compensation for all that was destroyed, nor even formally expressed any regret over

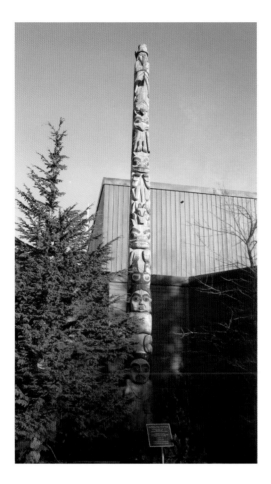

90 Nathan Jackson (Tlingit), with Steve Brown, Wooshkeetan pole, 1980. Centennial Hall, Juneau, Alaska, 2011. Photo by Aldona Jonaitis.

the action. All the Navy did, in 1982, was send a letter stating that the bombing, which was "an unfortunate event," "should never have happened." The descendants of the Angoon bombardment still await a formal apology.

So today the visitor to Juneau—and thousands of them arrive on the cruise ships every day from May to September—can stroll to Centennial Hall and discover by means of a totem pole the story of a nineteenth-century atrocity perpetrated by the U.S. military, learn of that community's ongoing outrage at those past events, and perhaps consider the merits of Angoon's continued demands for an apology.

CONCLUSION

PERHAPS THE SINGLE MOST IMPORTANT FACT THAT EMERGES FROM A study of totem poles is that *there are more totem poles standing today than there were a hundred years ago.* In the mid-1800s, Haida Gwaii could claim to have the most abundant number of poles. But by the century's end, full-size pole carving on those islands, as well as in other locations, had ceased, although miniature poles continued to be produced in various locations. Many old poles decayed as they stood before ruined houses in abandoned villages. Some new poles went up here and there, but except for the Kwakwaka'wakw, little time, energy, and money went into carving and erecting these monuments. And museums purchased many that were still standing.

Fast-forward one hundred years. Poles are everywhere. In parks. On museum grounds. In Native communities. In front of corporate headquarters. On city streets. At colleges and universities. And more go up every year. A good number of poles are copies of earlier ones. Most are quite faithful to their originals, but some, like Stephen Jackson's Burke Museum pole, are strikingly innovative. Other poles have no specific prototype, such as Tommy Joseph's K'aylaan pole in Sitka. Most of these adhere to traditional canons, but poles by Don Yeomans and Donald Varnell join Stephen Jackson's in their originality.

Contemporary totem poles are more varied in meaning than their sculptural antecedents, and many embody strong cultural values. Sovereignty, indigenous power, and cultural pride are central themes in numerous poles, including those from the Gitanyow replication project, the Alert Bay cemetery, the Health Clinic in Ketchikan, and the WPA projects. Mungo Martin's house, Susan Point's figures at the Vancouver International Airport, Tommy Joseph's K'aylaan pole, and Rick Beasley's culturally modified trees all assert

Native ownership of their culture and their land. Repatriation features prominently in the history of the University of Washington's Burke Museum posts, and the Eagle on the Decayed Pole in Prince Rupert. Some poles address specific, difficult issues, such as the deceit of those who stole the Seattle pole, the cruelty of the military in the Wooshkeetan pole, and the tragedy of substance abuse in the Wellbreity pole.

Other poles reflect the values of those who settled on Native land. Mourning cultural loss and the desire to retrieve remnants of the past stimulated white-organized pole-retrieval projects such as Sgaang Gwaii, Gitanyow, and the Sitka National Historical Park. A number respond to tourism, such as the "tallest pole" at Alert Bay, and the Totem Bight clan house and pole. Tourism was in part the stimulus for building Qay'llnagaay in Skidegate and setting up totem pole parks in Sitka and Ketchikan. Some poles have been appropriated by non-Natives as symbols of place: the Seattle pole, Tony Hunt's British Columbian centennial pole, poles as elements signifying Alaska in world's fairs, and Tony Hunt's Thunderbird post at Stanley Park.

The Native population on the Northwest Coast is growing, and art production, including the carving of totem poles, is flourishing. The totem poles of today, whether carved in traditional style or experimental to sometimes shocking degrees, are very much artworks of the present. While many refer back to historical prototypes, the fact is that today these numerous monuments visually address not just Native people, but everyone. These are not some archaic form of exotic culture from the vanished past but artworks that reside comfortably within today's globalized world.

SUGGESTED FURTHER READING

THERE ARE MANY BOOKS A READER INTERESTED IN TOTEM POLES might consult. A number address the topic of totem poles in general; these include Marjorie Halpin, *Totem Poles: An Illustrated Guide*, Vancouver: UBC Press, 1981; Edward Keithahn, *Monuments in Cedar*, Seattle: Superior Publishing Company, 1963; Edward Malin, *Totem Poles of the Northwest Coast*, Portland, OR: Timber Press, 1986; and Hillary Stewart, *Looking at Totem Poles*, Seattle: University of Washington Press, 1993. For a more thorough treatment of the totem pole from the perspective taken in this book, see Aldona Jonaitis and Aaron Glass, *The Totem Pole: An Intercultural History*, Seattle: University of Washington Press, 2010.

Other books concentrate on poles from various groups: Marius Barbeau, *Totem Poles of the Gitksan*, Ottawa: National Museums of Canada, 1929; Ira Jacknis, *The Storage Box of Tradition: Kwakiutl Art, Anthropologists, and Museums, 1881–1981*, Washington, DC: Smithsonian Institution Press, 2002; and Robin Wright, *Northern Haida Master Carvers*, Seattle: University of Washington Press, 2001.

Publications have also been devoted to totem poles that can be found in specific locations: Viola Garfield, *Seattle's Totem Poles*, Bellevue, WA: Thistle Press (new edition of 1940 original), 1996; Viola Garfield and Linn Forrest, *The Wolf and the Raven: Totem Poles of Southeast Alaska*, Seattle: University of Washington Press, 1948 (mainly about the poles in Ketchikan); Vickie Jensen, *Carving a Totem Pole*, Seattle: University of Washington Press, 1992 (the history of Nisga'a artist Norman Tait's totem pole at the Native Education Center at the University of British Columbia, Vancouver), and Jensen's *The Totem Poles of Stanley Park*, Vancouver, BC: Subway Books, 2004; George MacDonald, *Ninstints: Haida World Heritage Site*, Vancouver: UBC Press, 1983; Andrew Patrick, *The Most Striking of Objects: The Totem Poles of Sitka*

National Historical Park, Anchorage: U.S. Department of the Interior, 2002.

Several carvers have books about their works. For Haida Bill Reid, see Karen Duffek, *Bill Reid: Beyond the Essential Form*, Vancouver: University of British Columbia Museum of Anthropology, 1986; and Duffek and Charlotte Townsend-Gault, eds., *Bill Reid and Beyond: Expanding on Modern Native Art*, Vancouver, BC: Douglas & McIntyre, 2004. For more about specific Kwakwaka'wakw carvers, see Phil Nuytten, *The Totem Carvers: Charlie James, Ellen Neel, and Mungo Martin*, Vancouver: UBC Press, 1982.

Many books have been written about Northwest Coast art, several of which include information on totem poles. For late nineteenth- and twentieth-century art in British Columbia, see Ronald Hawker, *Tales of Ghosts: First Nations Art in British Columbia*, Vancouver: UBC Press, 2003. For a general survey of Northwest Coast art, see Aldona Jonaitis, *Art of the Northwest Coast*, Seattle: University of Washington Press, 2006.

This book has presented a good introduction to Northwest Coast Native history, and many books delve deeper into various aspects of this topic. For general works on the Northwest Coast, see Robert Boyd, *The Coming of the Spirit of Pestilence: Introduced Infectious Diseases and Population Decline among Northwest Coast Indians, 1774–1874*, Seattle: University of Washington Press, 1999; and Douglas Cole, *Captured Heritage: The Scramble for Northwest Coast Artifacts*, Seattle: University of Washington Press, 1985. For histories pertaining specifically to British Columbia, see Cole and Ira Chaiken, *An Iron Hand Upon the People: The Law Against the Potlatch on the Northwest Coast*, Seattle: University of Washington Press, 1990; Leslie Dawn, *National Vision, National Blindness: Canadian Art and Identities in the 1920s*, Vancouver: UBC Press 2006; Wilson Duff, ed., *Histories, Territories and Laws of the Kitwancool*, Victoria: Royal British Columbia Museum, 1959, and Duff's *The Indian History of British Columbia*, vol. 1: *The Impact of the White Man*, Seattle: University of Washington Press (reprint of 1964 original), 1997; and Robin Fisher, *Contact and Conflict: Indian-European Relations in British Columbia, 1774–1890*, Vancouver: UBC Press, 1977. For books on Alaska, see Ted Hinckley, *The Canoe Rocks: Tlingit and the Euroamerican Frontier, 1800–1912*, Lanham, MD: University Press of America, 1996; and Victoria Wyatt, *Images of the Inside Passage: An Alaskan Portrait by Winter and Pond*, Seattle: University of Washington Press, 1989.

Books have also been written about various specific topics covered in these pages. For more on Edward S. Curtis among the Kwakwaka'wakw, see Bill Holm and George I. Quimby, *Edward S. Curtis in the Land of the War Canoes: A Pioneer Cinematographer in the Pacific Northwest*, Seattle: University of Washington Press, 1980. The Harriman Expedition has been the

subject of two books: William Goetzman and Kay Sloan, *Looking Far North: The Expedition to Alaska, 1899*, New York: Viking Press, 1982; and Thomas Litwen, ed., *The Harriman Alaska Expedition Retraced*, New Brunswick, NJ: Rutgers University Press, 2005. For an analysis of the messages conveyed by world's fairs, see Robert Rydell, *All the World's a Fair: Visions of Empire at American International Expositions, 1876–1916*, Chicago: University of Chicago Press, 1984.

INDEX

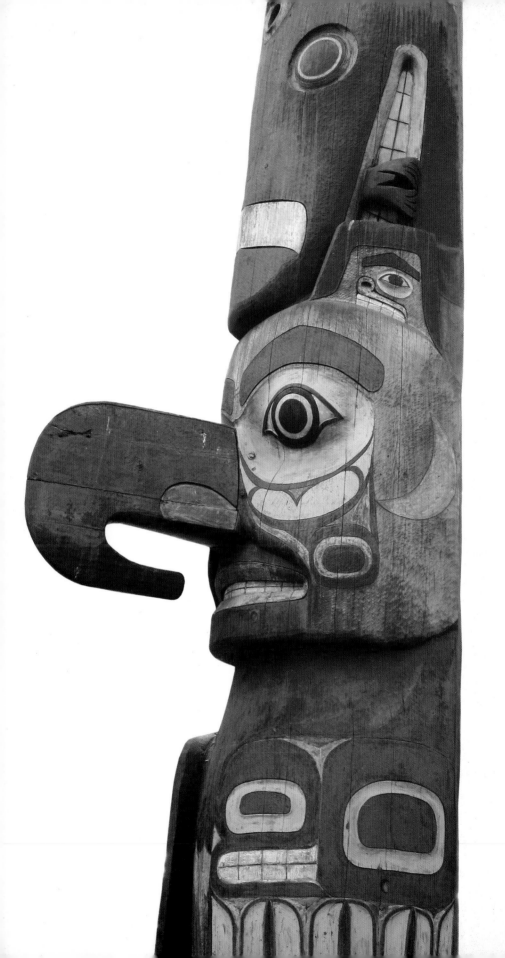